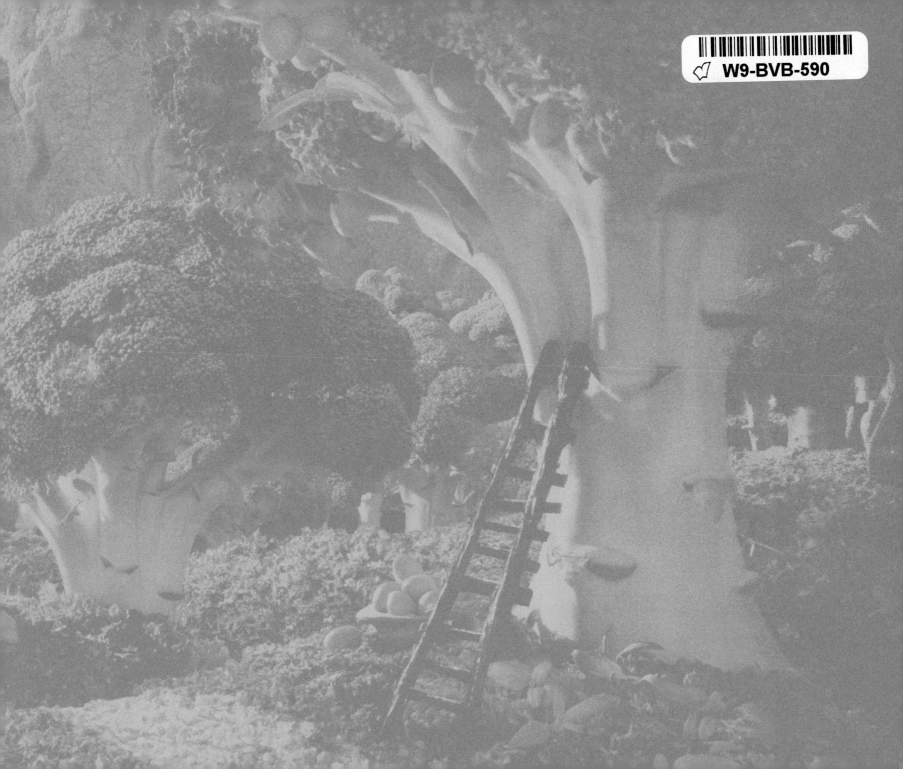

Carl Warner's
Food Landscapes

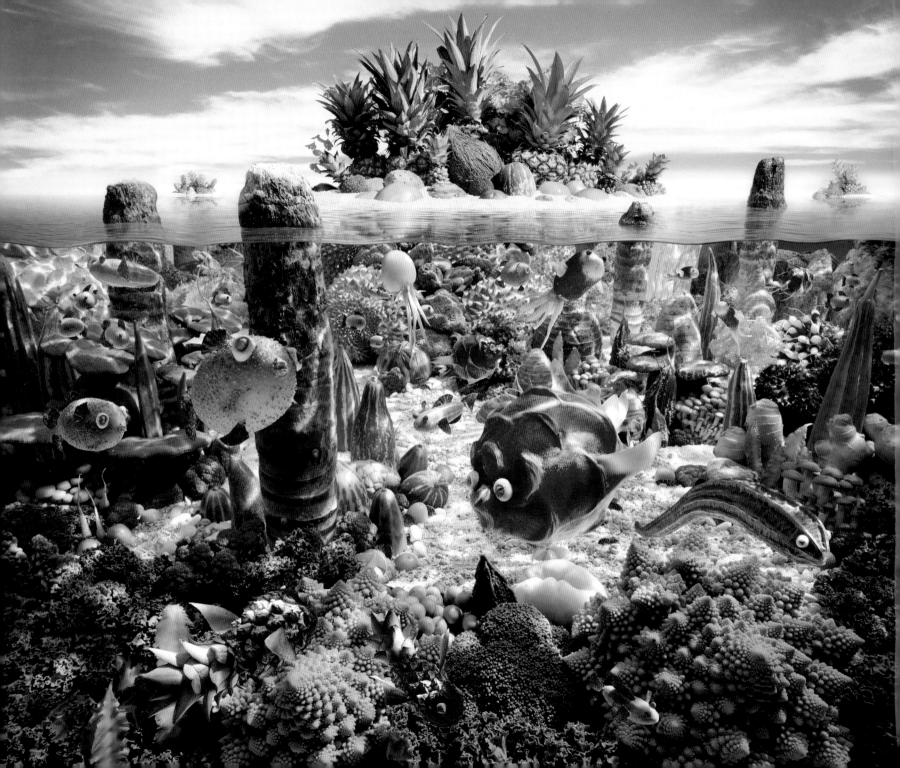

Carl Warner's

Food Landscapes

ABRAMS IMAGE, NEW YORK

Editor: David Cashion
Designer: Empire Design Studio / Gary Tooth
Production Manager: Ankur Ghosh

Cataloging-in-Publication Data has been applied for
and may be obtained from the Library of Congress.

ISBN 978-0-8109-8993-1

Printed and bound in China
10 9 8 7 6 5 4 3 2 1

Abrams Image books are available at special
discounts when purchased in quantity for
premiums and promotions as well as fundraising
or educational use. Special editions can also
be created to specification. For details, contact
specialmarkets@abramsbooks.com, or the
address below.

115 West 18th Street
New York, NY 10011
www.abramsbooks.com

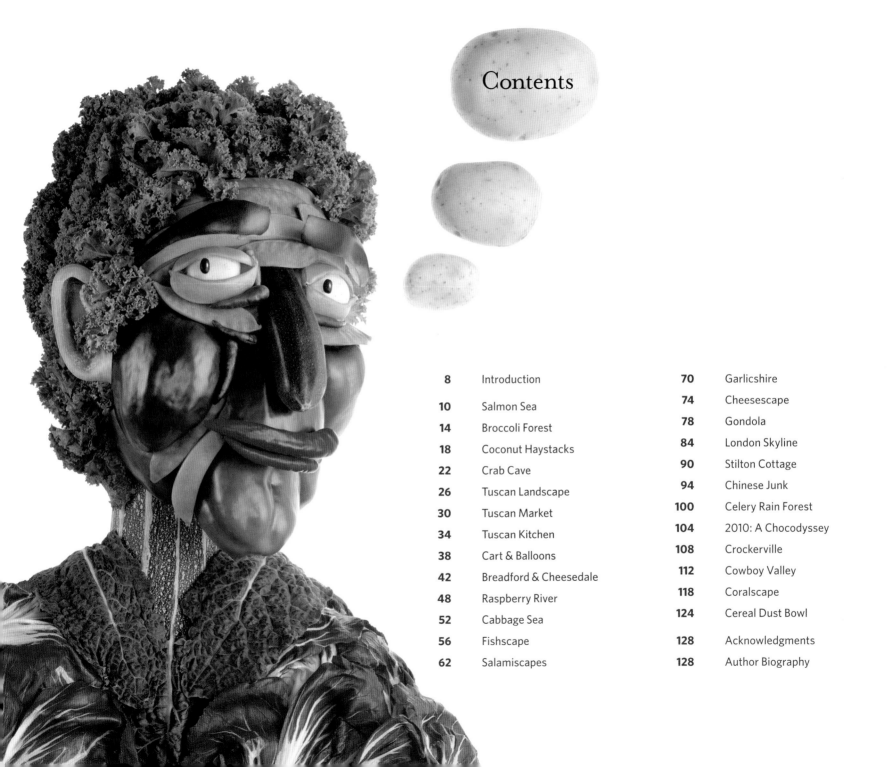

Contents

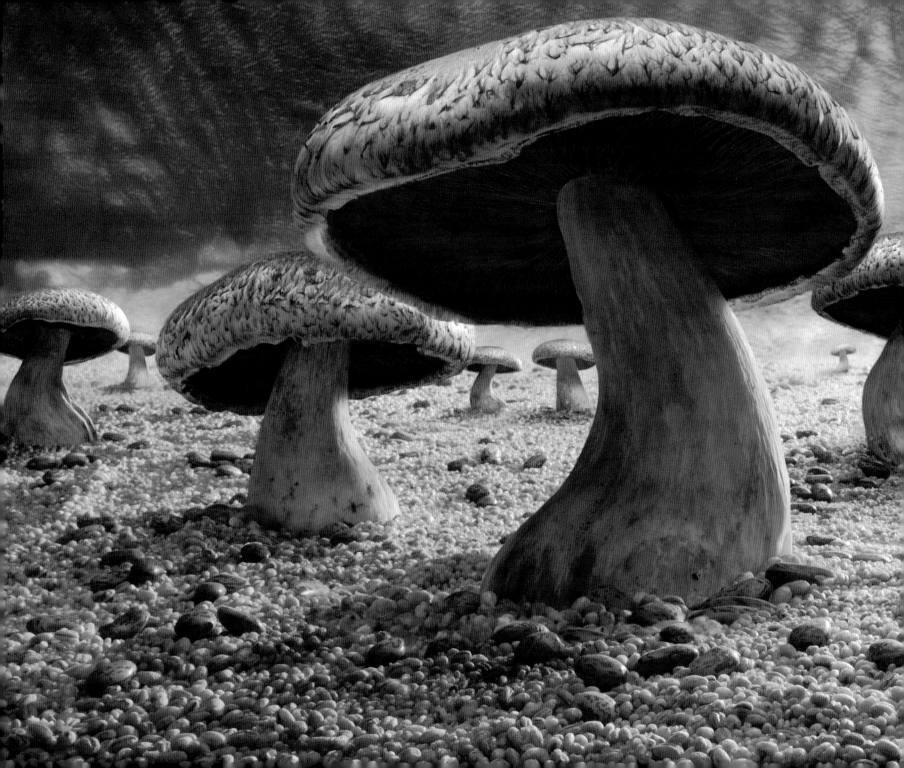

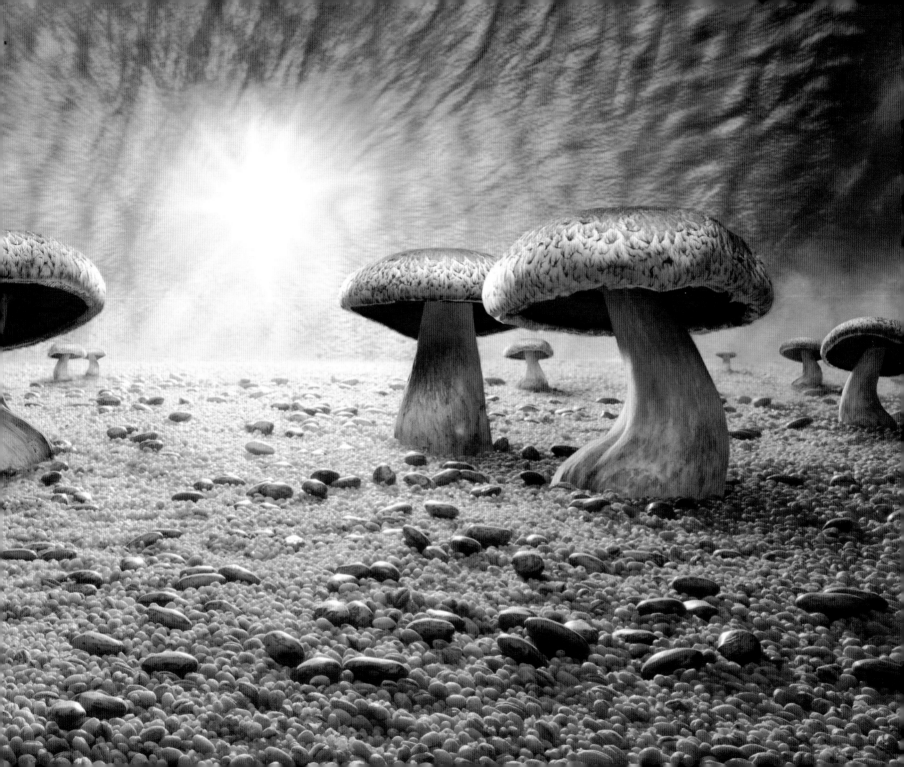

INTRODUCTION

MAKING LANDSCAPES OUT OF FOOD SEEMS A RATHER UNUSUAL THING to do for a living, and people often ask, "What made you start doing this?" It seems that the burning heart of this question is really the curiosity about what it is that motivates any human being to do something out of the ordinary, and my short answer to this is usually a simple, *because I had the idea and I chose to do something about it*. The longer answer is in the pages of this book, as I relive and revisit the ideas, inspirations, commissions, and creative processes that led to each finished piece. It can also be considered the story of the growth of this art form for me. I hope it proves both enlightening and entertaining.

Transforming one thing into another is nothing new to any of us: A few new tiles and a lick of fresh paint can transform a dreary kitchen into the heart of the home; some wooden decking and a few plants can turn a backyard into a tranquil garden sanctuary. I believe that creativity is in our nature, and is one of the greatest gifts we possess. The positive exercising of that gift has lead to the creation of some of the most wonderful aspects of human endeavor, the shared virtues of which can be found in art, architecture, film, music, and literature. I remember as a small child sitting with my father when he took a pencil and paper and began to make marks on a white page. As I watched various shapes appear, I was captivated by the process, by not knowing what it was, and imagining the infinite possibilities of what it might be. I eventually guessed what it was that he was drawing: a tank, sadly, a vehicle of war and destruction, but something little boys in the 1960s got very excited about. After that day, I was hooked. As an only child I spent a lot of time alone in my bedroom drawing and designing ships, spacecraft, futuristic buildings, and alien worlds. The walls of my room were covered with art posters of painters and illustrators such as Salvador Dalí, Patrick Woodroffe, and Roger Dean. For me, drawing and music were a means of escape into other worlds and alternate realities, and this provided the means to stimulate and exercise the muscles of my imagination.

This went on for years, until I discovered photography. I found that I could photograph the real world but make it surreal by the techniques and processes I was able to use in the camera and in the darkroom. I soon realized that this was a lot quicker than drawing, and I was able to develop ideas and concepts with greater ease. Although I had a lot to learn about the technical aspects of photography, I was enjoying this new way of making images and developing the skills to make them better. At the same time, album cover art was in its heyday, and graphic designers such as Storm Thorgerson of Hipgnosis were creating amazing surreal images using photography for bands like Pink Floyd. I knew then that this was what I wanted to do with my life.

After a foundation course at Maidstone Art College and a degree in Photography, Film, and Television at the London College of Printing, I soon found work as an assistant to photographers in the advertising industry. It was the mid-eighties and advertising was the new rock and roll. The London agencies were leading the world with boundless creativity and obscene budgets matched only by the egos of those who squandered their clients' money with ferocious hedonistic fervor. Thankfully, I managed to steer a fairly safe course through these times and emerged into

the nineties with a reasonable reputation as a creative still-life photographer who could make the mundane look interesting.

Toward the end of the nineties, the advertising business had become a fickle mistress who came and went as she pleased, leaving me and many others like me in a roller-coaster ride of famine and feast. As photographers (or "Smudgers," as we were often called), we were only ever as good as our last shot or latest idea, so there was always the pressure to think up new ideas or to create new imagery to "wow" the ad men with, in order for them to keep you in mind for their next campaign.

In the autumn of 1999, things were pretty quiet in my studio and I needed to come up with something different, something that no one to my knowledge had done. I was greatly inspired by the work of Tessa Traeger, a food photographer who published a book called *Visual Feast* in which she had made pictures using food. Most of these were very painterly and two-dimensional in construction. I wondered whether I might be able to take this further and create three-dimensional works using food, but it was only a thought and I didn't have any ideas about how I might achieve this.

Before we had the Internet to occupy most of our days, still-life photographers would spend a great deal of time wandering around markets and junk shops looking for oddities to photograph. It was one of these excursions that brought me to the mushroom stall of a fruit and vegetable market, where I found some amazing portobello mushrooms. Their curving trunks and parasol canopies reminded me of trees from some African savannah, and I wondered whether I would be able to create a tabletop scene with them that would give the impression of a much larger-scale landscape. So with a carrier bag full of mushrooms and a selection of bulgur wheat, rice, and beans to make a stony ground cover, I headed back to the studio to see if it would work.

That was how I began making food landscapes. I did one or two to start out with and then began to get commissions from advertising agencies and food clients throughout Europe, and by the end of 2007 I had accumulated enough of them to be considered a body of work, and then it really began to take off. I have learned that if you do one or two good pieces of work, people think you got lucky or see it as a fluke, but when you have twenty or so pieces of work depicting different scenes and locations with different food groups, ingredients, moods, colors, and lighting styles, people start to have confidence in that body of work, and give you recognition for it.

In January of 2008, I received an e-mail from a press agency that had seen the images on the Internet via one of those sites that trawl the Net looking for interesting material. The agency wanted to pitch my story and the food landscape images to newspapers, as they thought it would make for an interesting article. I happily agreed but added that I had been doing these for ten years and I doubted whether anyone would be interested. I was so very wrong. On the thirteenth of January, the *Sunday Times* ran a quarter-page article and on Monday the fourteenth, I had a full page in the *Daily Mail*, the *Mirror*, and the *Sun*. I got to my studio to receive a barrage of calls from TV and radio stations. BBC and ITV news crews came to interview me at the studio and at 4:00 p.m. I was whisked off to the *Richard & Judy* show for a live interview with them. That was quite a day!

After that the images were blogged and PDFs sent around the globe in viral e-mails. I was the topmost e-mailed article on the BBC Web site for about five days, and my in-box was full each morning with interest from all over the world that would take me the best part of each day to read and respond to. Schoolteachers began sending me photos of food landscapes made by their children in art classes, painters in South America wanted to collaborate with me on projects, people wanted them for chopping boards and jigsaw puzzles, calendars, and "in flight" menus. I began to sell prints of the work and direct TV commercials where we traveled through the landscapes with a snorkel lens on a film camera; I've had exhibitions at food fairs and gastronomy events throughout Europe and even in Hong Kong. But the one thing that I hadn't done as yet, and the one thing that everyone has asked for, is a book. So finally, here it is.

Many of the scenes in these pages were commissioned by various advertising agencies and food clients, some were favorite ideas of the book's publisher, and some of them were self-initiated to see if I could expand and explore new techniques and ideas. I work closely with model makers, food stylists, and retouchers to create the final images. Without their help, these pictures would simply have never been made as well as you see them now.

The following chapters present a selection of my favorite images from the collection. And as it is customary these days to show ones "eco" credentials, I would like to point out that although some of the food has to be disposed of, the edible leftovers are shared out amongst the wonderful team of people I work with or picked up by a local charity shelter. In the meantime, I hope that you will appreciate the fruit (and veggies) of our labors so far, and enjoy exploring the scenes as much as we have enjoyed creating them.

Carl Warner

Salmon Sea

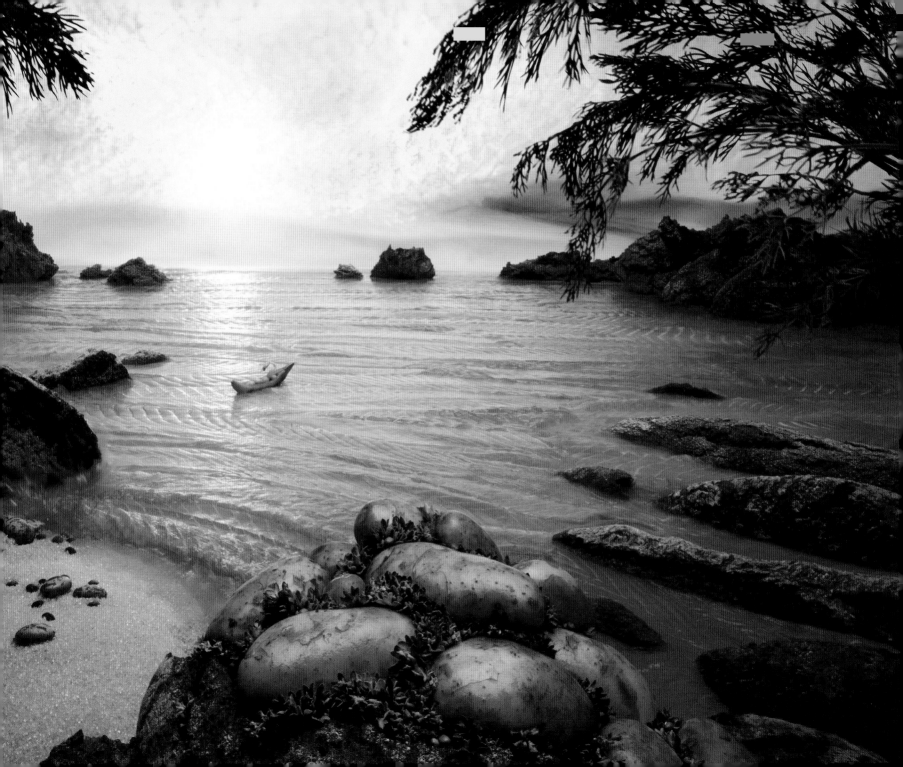

SALMON SEA

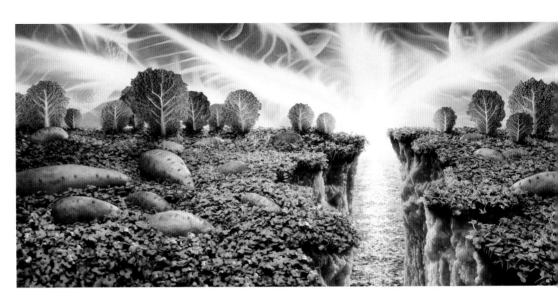

In the days before high-end retouching was available at reasonable prices to photographers in terms of computer power and software, we would work with companies that had invested heavily in this technology, sitting next to an operator who retouched our images while we watched the clock tick away our bank balance.

There was, however, a wonderful oasis in this digital minefield, a small company called Alchemy. It was one of the more relaxed retouching houses and you could chat with other photographers and art directors quite openly, and this in my view led to a more creative hub, which inspired and excited many of the people who became regular faces there during the late 1990s. There was, however, one other great attraction in working with Alchemy, and that was the fact that the Eagle, London's first real "gastro pub," was situated next door, where many an afternoon was lost in great food, wine, and laughter.

A little farther up Farringdon Road was an amazing Italian deli that provided me with a whole Parmesan drum, which I had them split apart to reveal what became the texture of the walls of a food landscape called Parmesan Gorge, and while we were retouching this image at Alchemy, it caught the attention of an art director from Finland who was there on another job. He loved the food landscape concept and thought it would be perfect for a client of his who wanted to advertise a brand of butter.

A few weeks later, he came back with a sketch using the ingredients of a typical meal in Finland: salmon, new potatoes, dill, and a dense, dark soda bread. His drawing showed a salmon steak as a lake with potatoes as rocks, but I could not see how I could make a single piece of fish look like a lake; it was too small in terms of scale and I could not imagine the scene working. I was on the brink of turning the commission down, as

I did not feel confident that I could pull it off, when I spotted the texture of some smoked salmon over lunch at the Eagle. Although not a huge fan of smoked salmon at the time, I decided to order the dish for myself in order to take a closer look.

The smoked salmon arrived as a casual pile of strips soaked in lemon juice, speckled with black pepper, and tumbling over torn pieces of crusty brown bread with a snapped sprig of dill thrown on top. Shafts of bright sunlight poured in through the tall windows of the Eagle, and much to the bemusement of my fellow diners, I picked up the plate and angled it to see how the light played on the surface of the fish, and saw how remarkably the texture and patterns looked like the surface of water. It was a "eureka" moment as I realized that I might be able to make this work after all. So I accepted the commission with a view

that if it didn't work, then I wouldn't charge them for it (not that I told them that, of course!).

As the day of the shoot arrived, I was feeling quite apprehensive despite my eureka moment. I bought a large sheet of brushed aluminium to lay the salmon onto so that the light would reflect back through it and emphasize its translucence and color. Indeed, the color was a bit of a concern at first, as the ocean is not the orange color of smoked salmon … except of course when a sunset is reflected into it! So that dictated how the scene was to be lit, and following the arrival of the dark Finnish soda bread (flown in especially), the rocks and land began to take shape.

As my food stylist, Joyce, began to open packet after packet of the rather expensive smoked salmon, I began, tentatively, to lay the strips down from left to right across the direction of the tungsten studio lamp I was using for the sun. Thankfully, the effect I had seen over lunch was happening again, only to a greater extent due to the scale of the set (approximately seven feet across and four feet deep).

The feeling of excitement was incredible as I pulled the first 10 x 8 Polaroid. It was as if we had discovered a new color. I have to admit, though, that I saw this as a bit of a "one off" event, more a fluky stroke of luck than any kind of genius. The magical illusion created from a few simple ingredients was going to be a very hard act to follow, and to some extent, I don't think I have since made an image with so few ingredients that works so well.

As we added the sugar beach, dressed the potato rocks with flowering parsley,

INGREDIENTS

Sea – smoked salmon
Rocks – dark soda bread
Sand and pebbles – sugar, pinto beans
Foreground rocks – new potatoes, parsley
Foreground trees – dill
Boat – pea pod, bean sprout
Sky – side of salmon

and added the sprigs of dill as foreground trees, it seemed obvious that there was something still missing, and as I turned to see what other ingredients we had left, Joyce opened her hand to reveal a beautiful green pea-pod boat. It was an inspired moment and became the focal point of the scene. I later shot the side of a whole salmon, which we added at Alchemy to create the sky, in which the scales and the fin brought subtle details to the shot, which many people still don't see until it is pointed out to them.

So I had moved on from the first surreal worlds of trippy mushroom panoramas and deep, other worldly Parmesan gorges to create a scene that looked more like the real world, so much so that someone once told me (while looking at the image) that the shot was taken in a region of southern Portugal called the Algarve, and that he had been there on vacation the previous year, having stayed in a villa a few miles up the coast! I suggested that unless this villa was made of cheese with a pasta roof, he should take a "closer" look at the picture.

Top: A detail of the pea-pod boat and the salmon sea.

Bottom: One of the first sketches of the scene.

Opposite: The second food landscape I made, which again looked like some kind of surreal extra-terrestrial vista.

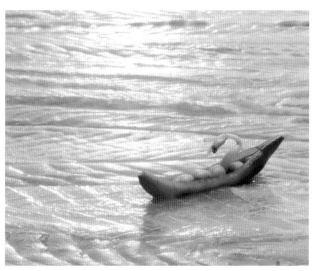

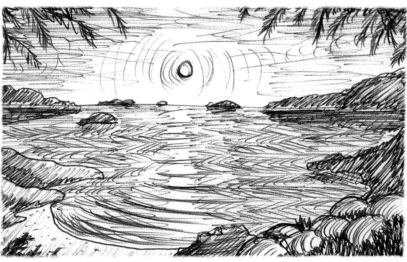

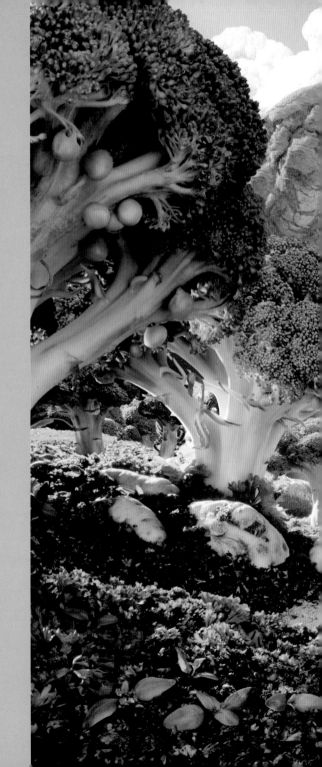

Broccoli Forest

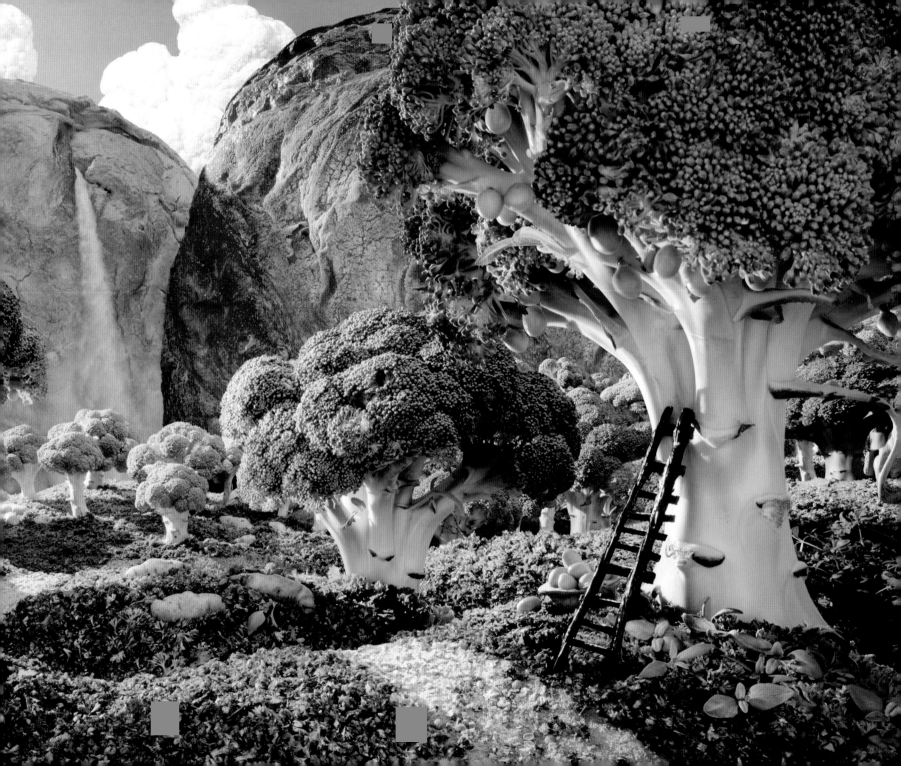

BROCCOLI FOREST

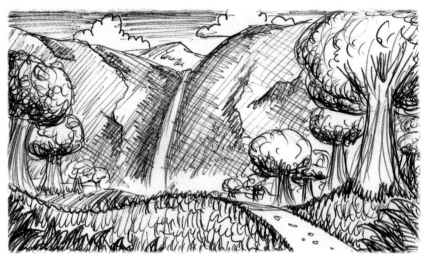

INGREDIENTS

Trees – *broccoli*

Ground cover – *chopped parsley, broccoli heads*

Plants – *fresh herbs*

Small foreground rocks – *Jerusalem artichokes, potatoes*

Pathway – *cumin and turmeric with fennel seeds*

Rocks – *crusty bread*

Waterfall – *sugar*

Clouds – *cauliflower*

The food landscapes I create are not always inspired by the physical world that I have seen or visited; many of them come from paintings, films, and even dreams from the past. I remember when I was a small boy, and all televisions were black and white, I was taken to the cinema to see *The Wizard of Oz*. I'll never forget our shock as the film turned from the monotone black and white of Kansas to the startlingly vivid colors of Oz. Here was the stuff of dreams and nightmares that seemed more real and alive compared to the blandness of our every-day world, like a glimpse of heaven and hell in glorious Technicolor. Instead of feeling happy for Dorothy being reunited with her family, I remember feeling sad to have been brought back from that magical kingdom, so perhaps this is why I have returned to Oz in my imagination by making this world out of food.

There is a scene in the film in which Dorothy comes across the Tin Man in an enchanted forest where the trees come alive and throw their apples at her, and as I look back, it is clear that the Broccoli Forest is built from the memories of that scene. The turmeric path is of course the yellow brick road, which winds its way through fresh herbs and Jerusalem artichoke rocks, toward a towering sugar waterfall set within the bread-loaf mountains, and the broccoli trees that fill the valley floor have peas in their branches to throw at us.

The other inspiration that flavored the Broccoli Forest was the work of American photographer Ansel Adams, and in particular the magical light and landscape he captured in the Yosemite Valley. Photographing these beautiful and picturesque scenes in black and white gave them a graphic surreality that I believe they would have lacked if photographed in color, as they would have reverted back to the blandness of the pretty picture postcard, despite the awesome beauty of their content and composition. In a way, this aesthetic is the opposite effect of Technicolor in *The Wizard of Oz*. Here, the real world becomes a graphic fantasyland illustrated by light and shade, where composition and form are punctuated with the

Right, top: A close-up of the vanilla-pod ladder and walnut-shell basket filled with peas.

Right, bottom: Cauliflower clouds above and sugar poured from a jug to form the waterfall.

Below: When seen in black and white, the scene resembles an Ansel Adams view.

Opposite: An early sketch of the scene.

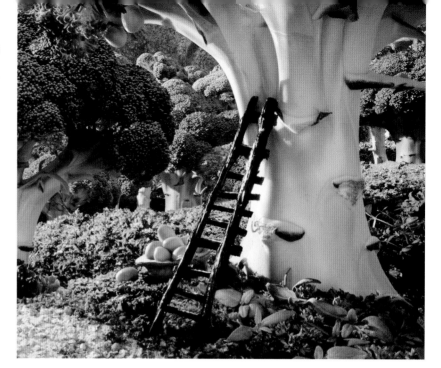

simplicity of tone and contrast, and without the distraction of color.

As I built and composed my forest on a tabletop in the studio, my goal was to combine the graphic simplicity that Adams achieves with his great eye for composition, together with the vivid colors and surreal nature of using food to construct it. The acid test for me was to remove the color from the final image on the computer screen to see how much it resembles the work of Adams. I hope you will agree that it's not a bad attempt, considering it's only broccoli and bread!

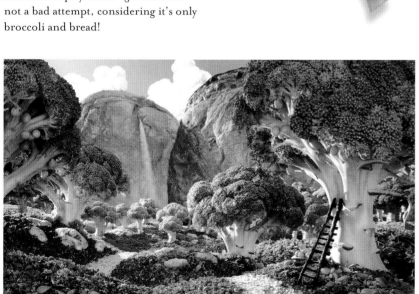

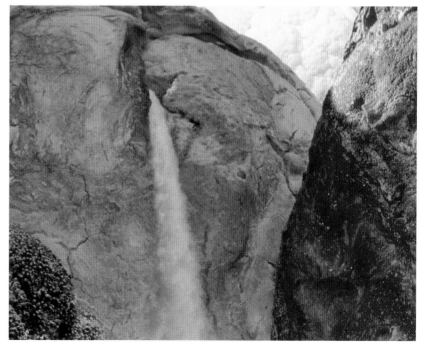

Coconut Haystacks

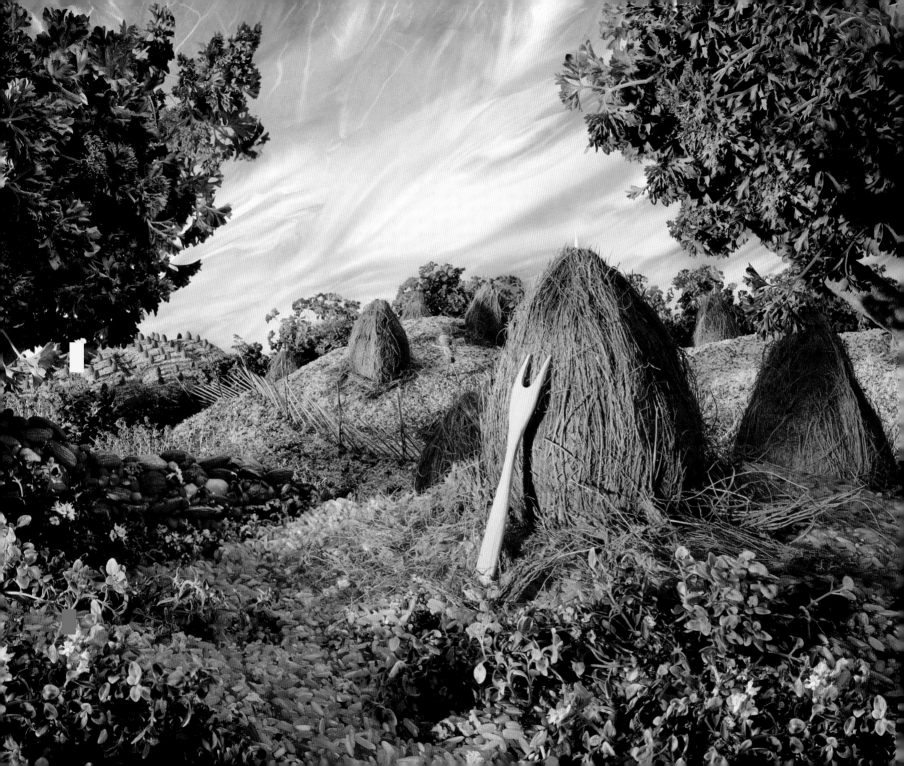

COCONUT HAYSTACKS

INGREDIENTS

Sky – *radicchio, red cabbage leaves*

Trees – *parsley with horseradish trunks*

Dry stone wall – *various nuts such as almonds, hazelnuts, Brazil, and pine nuts*

Foreground foliage – *flowering thyme, parsley*

Haystacks – *coconuts with wooden fork*

Distant haystacks – *toasted almonds*

Hills – *cob loaves of bread*

Fence – *cocktail sticks*

Scarecrow – *monkey nuts*

Ground cover – *rice*

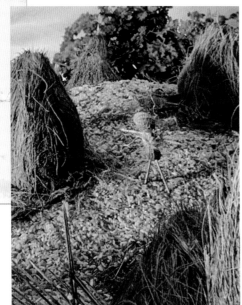

Left: A detail of the monkey-nut scarecrow.
Right: An original sketch of the scene.

This was yet another commission for the butter company in Finland from art director Arto Komulainen. Known by his friends as Arti, he is a well-known creative figure in the Finnish advertising industry, both in music and art, and I owe him a great debt of thanks for helping to get so many commissions during the early years, which helped me to develop the work in terms of ideas and techniques. Looking back, it is clear to me now that he saw the possibilities of where this could go long before I did. This particular scene started out as very much his concept, as he had spotted how much a coconut looked like a traditional haystack and wanted to use this idea in a new food landscape for his client. By this time we had stopped trying to relate the images to some kind of meal or recipe and were more concerned with exploring the technique and experimenting with different ingredients to see what could be made with them.

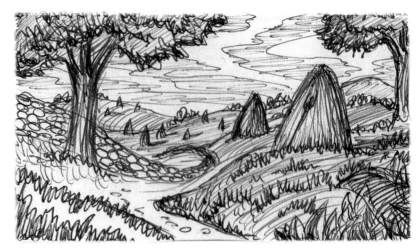

A close-up of the horseradish tree trunk and almonds for the distant haystacks.

Taking haystacks as one of the focal points, I made some sketches that incorporated a tree and a dry stone wall made of nuts to form a composition that created a geography around the haystacks, and a location that looked more familiar and realistic. At this stage I was not using model makers to help create the scenes, but relied on my food stylist, Joyce, to help me make things such as the wall, while I fumbled the rest of the landscape together from modeling clay and by laying fabric over blocks of wood. When I look back at these early works, it frightens me to think how little thought and preparation went into the

pieces compared to all the planning and testing that I do for them now. Things were just thrown together to see if they would work, and as Joyce would bring a whole pile of ingredients to the studio, we were able to try out different ideas when some things didn't work.

This was a very exciting time, as I was also starting to get ideas and inspiration for other landscapes during these early experimental phases, and this encouraged Arti to head back to Finland with new ideas for the next image in the campaign, which by this time had started to win awards in Finland and was becoming very popular with the public there.

There were several things that worked well in this image, and most of these were by chance. For example, Joyce managed to get hold of flowering thyme, which is something I have never seen since, and these miniature flowers were perfect for the scale of the set, bringing splashes of color and detail to the foreground and wall. The tree trunk was a horseradish root, which had a separate branch to make it more tree-like, and the almonds we used in the wall we noticed had a striking resemblance to the coconut haystacks, so they were also stuck to the distant bread hills to look like mini versions of haystacks.

All these happy accidents that seemed to come together by chance helped make an image that appeared to capture a look, which clearly showed a more mature and sophisticated step forward in both the complexity and richness of detail. For me this was a real progression in the technique, and I was starting to see what maybe Arti had seen all along, a refinement of the process that would take things to another level, that would allow me to be more inventive and innovative, making this more than just photography, but an individual art form that I could cultivate into a body of work.

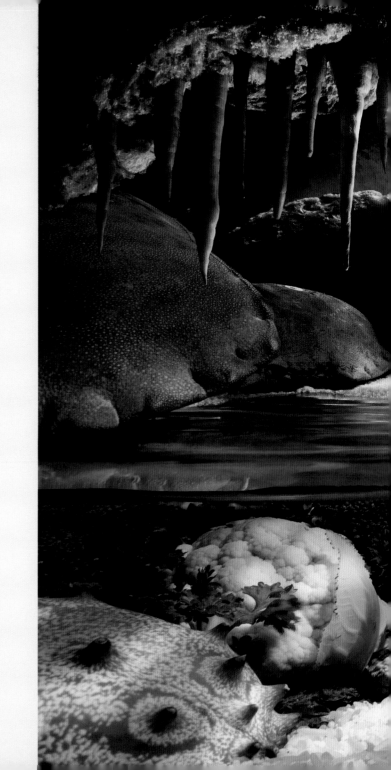

Crab Cave

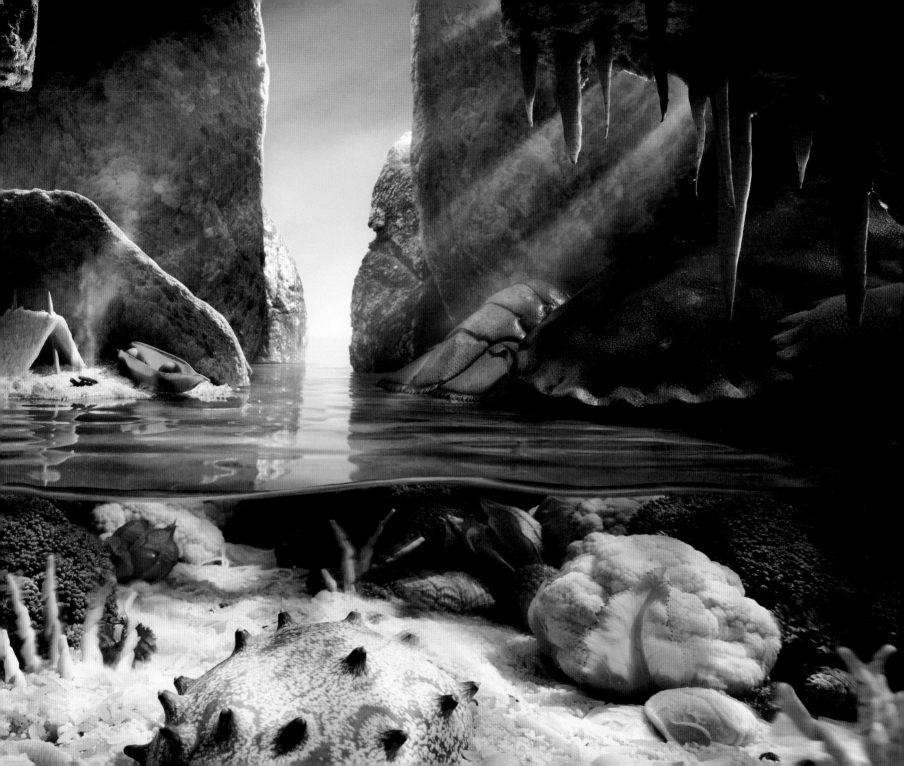

CRAB CAVE

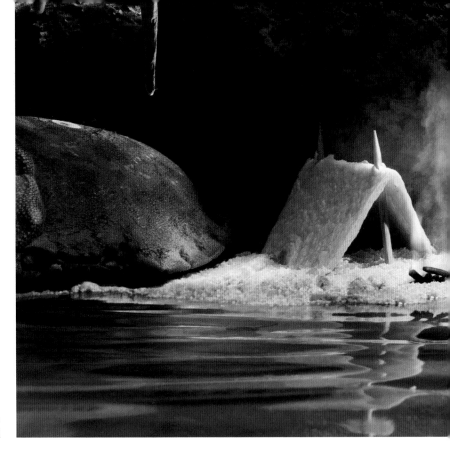

The last of the commissions from Finland was a semiunderwater scene where vegetables would be chosen to look like coral and shells on the seabed. The overall idea was hatched from using carrots as stalactites in a cave made of bread to once again simulate rock formations. To elaborate on this, we incorporated the underwater element in order to give the scene an extra layer of interest and depth to the image. I also wanted to create a resting place in the final ad for our "pea-pod boat," which we had seen in the first ad of the campaign, Salmon Sea.

The thought of using a large water tank filled me with dread, as I knew it would be hard to compose the image without things floating around and disintegrating, causing the water to cloud. The solution was a simple idea of suspending a sheet of rippled glass over the underwater part of the set, which, when viewed side on, would create the illusion of the surface of the water. This had the added advantage of not only coloring the seabed with a blue-green tinge, but also fragmenting the light to give dappled ripples of concentrated sunlight, which adds to the undersea look. This was a technique that I would later use on the coral island scene, as its effectiveness was much too good to be used only once.

As I began to assemble the set, I remember feeling quite nervous about making this visual illusion work. It was something I had never done before and although the idea worked in my head, one is never certain that everything one thinks of will work out in practice. As I began to assemble the basic ingredients to form the structure of the scene, I remember Arti watching over my shoulder and breathing down my neck, which didn't do a great deal for my confidence, especially when the first few Polaroids I pulled didn't look so great.

INGREDIENTS

Cave walls – bread
Cave rocks – crabs, lobster
Stalactites – carrots
Boat – pea pod
Tent – soft flour tortilla
Beach – couscous
Fire – cloves
Coral – broccoli, cauliflower, Kiwano fruit, trofie pasta swirls, lychees, physalis
Sand – rice, small pasta shells
Shells – whelks
Plants – parsley

Above: A close-up of the tortilla tent showing the final resting place for the pea-pod boat.

Right: An early sketch of the scene.

It wasn't going according to plan, and as I needed time and space to think, I had to ask dear Arti to have a nice cup of tea in the office area of the studio before I became violent toward him. He kindly agreed and politely left me to simmer down and get on with the job. An hour or so later, the scene was taking on a much better shape, and I asked him to come back into the studio to see the vision in my head through the back of the camera. Several 10 x 8 Polaroids later, and the shot was in the bag. Smoke from the fire and a few beams of light from holes in the roof of the cave were added in post production to complete the final touches.

Upon reflection, I could have added a few fish into the undersea part, but over the years no one has commented on the need for them, so I've assumed that it really wasn't necessary. At the time, I felt it was one of the strongest images of the series, as it opened up new ideas about seascapes and underwater scenes, and I started to realize that there was much more to be done, and many more places to go to with the food landscape concept.

However, as the landscapes were so costly to produce, I never really considered the possibility of doing more unless they were to be commissioned, and the thought of funding them myself seemed ridiculous, as Finland appeared to be the only client who was interested in using the idea. Perhaps if I had thought less as a commercial photographer and more as an artist, I would have invested more in the work and the development of it, but my low level of confidence and self-belief coupled with my lack of faith meant that I was more focused on securing the bread-and-butter jobs than cultivating the fruit for the jam.

The result of this wrong thinking meant that there was to be a few years' gap before I was to do the next landscape, and these few years were without a doubt the worst of my career as a photographer, as I was close to bankruptcy both creatively and financially. It was the emotional support of my wife, Helen, who worked hard to keep me afloat, and the fact that I turned to God instead of drink that eventually brought me out of the darkness of my crab cave and back up into the light of my broccoli-covered mountain once again.

Tuscan Landscape

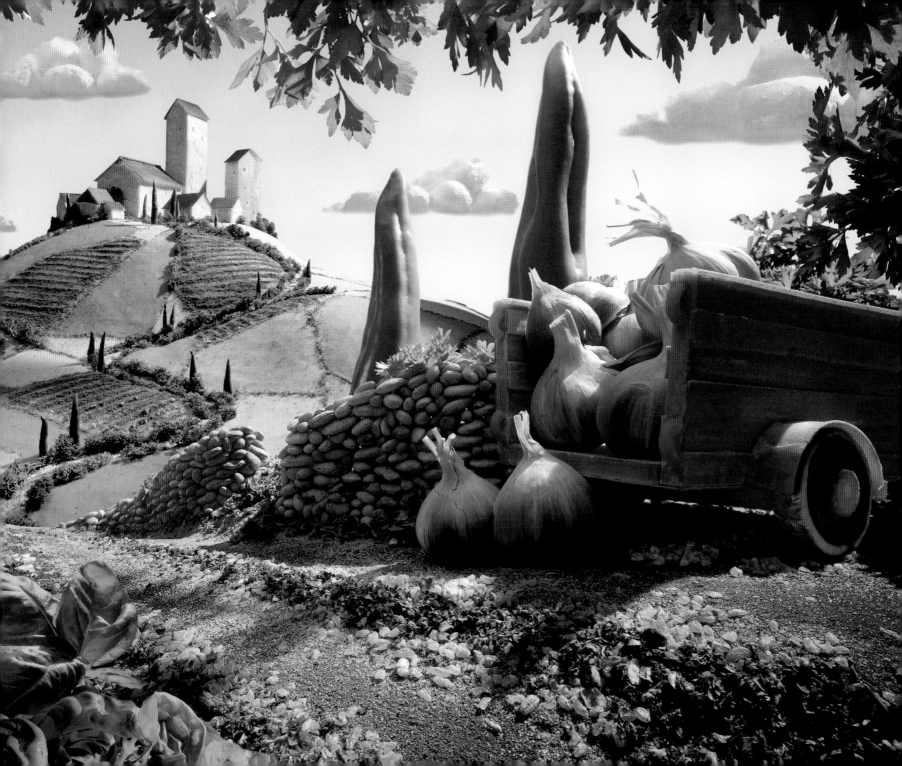

TUSCAN LANDSCAPE
(Tuscan Triptych Part 1)

One of my favorite places on the planet has to be Italy, a land of beautiful, sun-kissed people who enjoy a country that was home to one of the greatest empires that at one time ruled most of the civilized world. From its mountains and great lakes to its awe-inspiring historical cities, Italy is bursting with a culture rich with the legacy of some of the greatest artists, painters, sculptors, and architects the world has ever known.

It's no wonder then that this influence has fashioned a people so well blessed with style and great taste. Their designers are some of the leading names in the car industry—Ferrari, Maserati, and Lamborghini to name a few—as well as in the fashion industry—Cerruti, Fendi, Gucci, and Dolce & Gabbana. Indeed, in all aspects of modern design, from furniture to luxurious yachts, the words "Italian design" are synonymous with excellence and beauty. They simply make looking good an art form that I believe comes to them so naturally and effortlessly due to the influence of their surrounding environment and rich cultural heritage.

Italy also boasts one of the greatest and most prolific food cultures in the world. There is hardly a major city on the globe that doesn't have one if not many Italian restaurants and not a chef that hasn't been influenced by the great spectrum of Italian gastronomy.

There is a wonderful balance to Italian cuisine, simple and perfectly combined in terms of how it looks and tastes. From the simplicity of cooking meat or fish with olive oil and garlic to the incredible taste of balsamic vinegar from Modena or ham from Parma, combined with the freshest greens or wonderful cheeses (such as Parmesan, ricotta, and dolcelatte), or the infinite variety of delectable pasta, Italian cuisine is second to none. The following three images are a tribute to Italy and the Italian way of life.

INGREDIENTS

Trees and foliage – flat-leaf parsley, curly parsley, basil
Cypress trees – Romano peppers, green chilies
Cart – dried pasta
Cart wheel – mushroom
Sacks – garlic bulbs
Wall – pine nuts
Ground – fresh pasta covered with cinnamon, risotto rice, chopped herbs
Hill and fields – fresh pasta covered with chopped herbs
Hilltop village – Parmesan buildings with red pasta roofs
Clouds – mozzarella balls

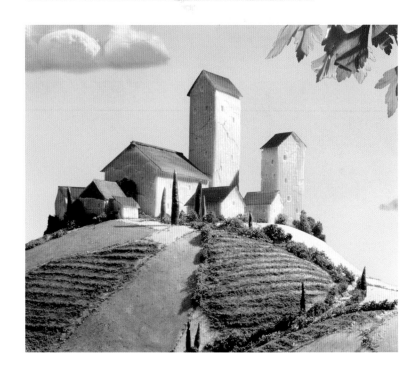

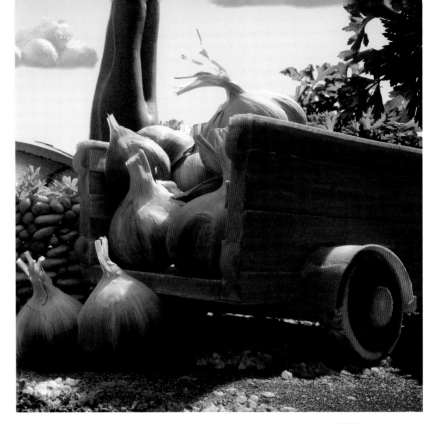

The first image captures the landscape of Tuscany, where medieval towns and villages such as San Gimignano crown the hilltops with their limestone walls and terra-cotta roofs. In the image, our village was made from blocks of Parmesan and pomodoro pasta roof tiles. The road leading up to the village is lined with green chilies to represent the cypress trees that line the snaking roads to places like Volterra, where countless European car ads of the 1980s were shot. Our hills were sheets of fresh pasta, rolled smooth and laid onto carved blocks of polystyrene and dressed with freshly chopped parsley.

The image was shot in two parts: The foreground scene shows a pasta cart with a mushroom wheel that is being loaded with garlic bulb sacks to take to market. In order to maintain the scale of the scene, we used green Romano peppers instead of chilies for the cypress trees and a dry stone wall made from pine nuts, which hugs the side of the dirt track road that takes us on our journey through the landscape to the hilltop town.

Fresh herbs such as parsley, basil, and thyme provide the foliage, and the image is finished off with mozzarella clouds, which were shot on glass and float silently above the land in the early-morning sunshine.

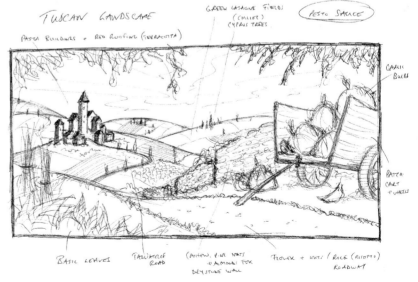

TUSCAN LANDSCAPE

PASTA BUILDINGS + RED ROOFING (TERRACOTTA)

GREEN LASAGNE FIELDS (CHILLIES) CYPRUS TREES

PESTO SAUCE

GARLIC BULBS

PASTA CART + WHEELS

BASIL LEAVES

TAGLIATELLE ROAD

(CASHEW, PINE NUTS + ALMONDS FOR DRYSTONE WALL

FLOUR + NUTS / RICE (RISOTTO) ROADWAY

Tuscan Market

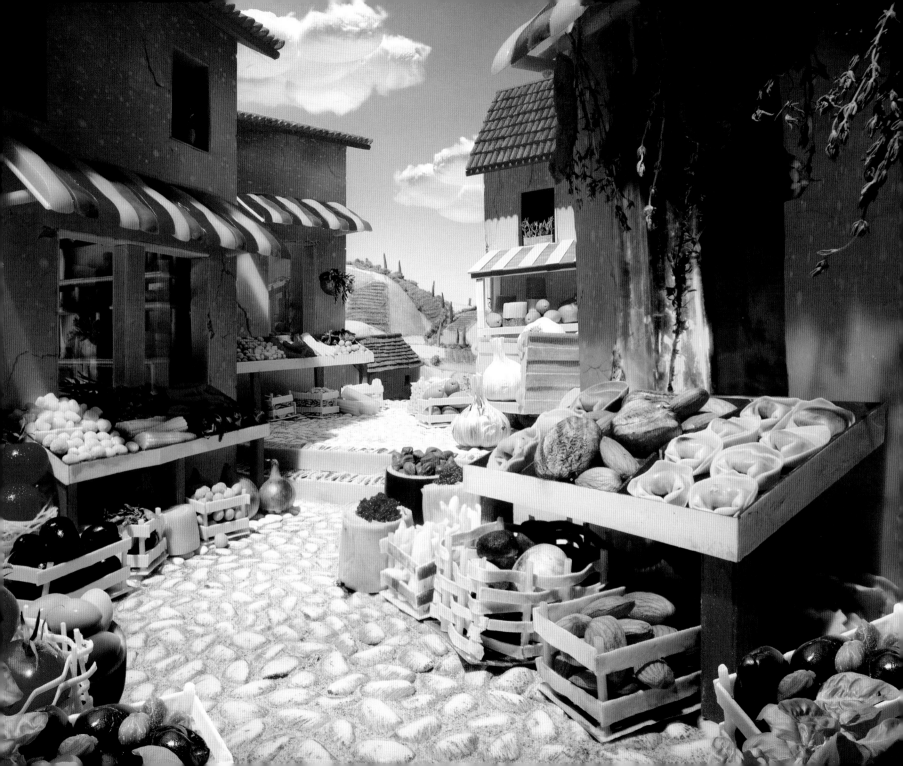

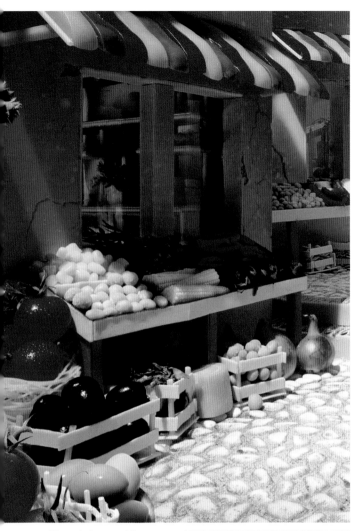

TUSCAN MARKET
(Tuscan Triptych Part 2)

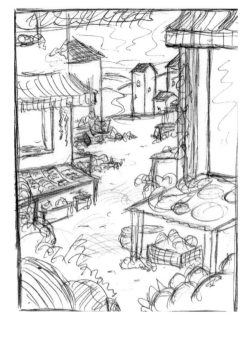

In the second part of this trilogy, we arrive from our journey through the country-side up the pasta hill at the center of our hilltop village. Here we find a typical Tuscan market adorning the cobbled streets, in a visual feast of Italian ingredients. As it took some time to make the journey here, the sun is now much higher in the sky and so the colors and shadows are much brighter and sharper in the midday sunlight.

The set for this scene began as a series of polycard walls and frames that were cut and placed in front of the camera lens in order to achieve the right size and proportion of the buildings in terms of scale and perspective, before Simon the model maker could begin cutting the Parmesan cheese blocks with which to clad the walls and window frames. He then set about making baskets and tables from dried pasta as well as the rigatoni-tiled roofs. Cannellini beans and whole-wheat flour were stuck to the baseboard to give us the cobbled street, and a bottle of olive oil provided the shop window with glass on the right-hand side.

Once all the buildings, baskets, and tables were in place, I began to do my favorite part: dressing the set with all the smaller ingredients that add the color, texture, and detail needed to bring the scene to life. I have to admit that this is a particularly obsessive part of the shoot for me, as nothing is just thrown in! I spend ages with tweezers, small paintbrushes, and surgeon's scissors, turning peas

Above: A close-up of the vegetable stalls and the windows that reveal the dresser inside the Tuscan kitchen.

Right: A 10 x 8 Polaroid of the scene made from polycard.

Far Right: My first sketch of the scene.

INGREDIENTS

Clouds – *mozzarella balls*

Hills – *fresh pasta, parsley hedging*

Cypress trees – *green chilies*

Roofs – *red penne pasta, red lasagna*

Buildings – *Parmesan*

Awnings – *yellow, red, and green peppers (capsicums), red and yellow lasagna*

Flowerpot – *olive and parsley flowers*

Wall baskets – *mushrooms with parsley*

Baskets, cart, and display boxing – *dried lasagna, tagliatelle, pappardelle, fettuccine, linguine, spaghetti*

Barrels – *artichoke hearts, eggplants, filled with sun-dried tomato paste, capers, olives*

Food on display – *tortellini, almonds, mushrooms, trofie pasta, black and green olives, cherry tomatoes, peas, sweet corn, spinach balls, chilies, baby corns, celery, shallots, ravioli, basil, asparagus, carrots, garlic bulbs, leeks, oregano, sun-dried tomatoes*

Window on right – *olive oil bottle*

Cobbles – *pinto beans*

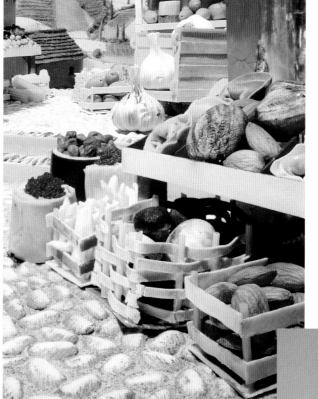

Left: A close-up of the dried pasta baskets and the cart from Tuscan Landscape unloading its garlic-bulb sacks.

Below: A detail of the pasta-tiled roof.

Far Left: A Polaroid of the set before dressing with all the ingredients.

toward the camera, brushing rice into pretty piles, and pruning herbs to form the most aesthetically pleasing of shapes. I believe that this attention to detail is vital in order to ensure the most crafted and considered look to the composition of the shot, as well as the most natural look.

Peering over the mozzarella clouds to our Tuscan market scene below, we see our pasta cart from the previous scene offloading the garlic bulb sacks to be sold in the market square, and beneath the tricolor pepper awnings we see through the window the shapes of a vase and dresser in a Tuscan kitchen, where the food bought from the marketplace will be gathered and cooked for a typical Italian meal, as we shall see in the last of our three Tuscan scenes.

Tuscan Kitchen

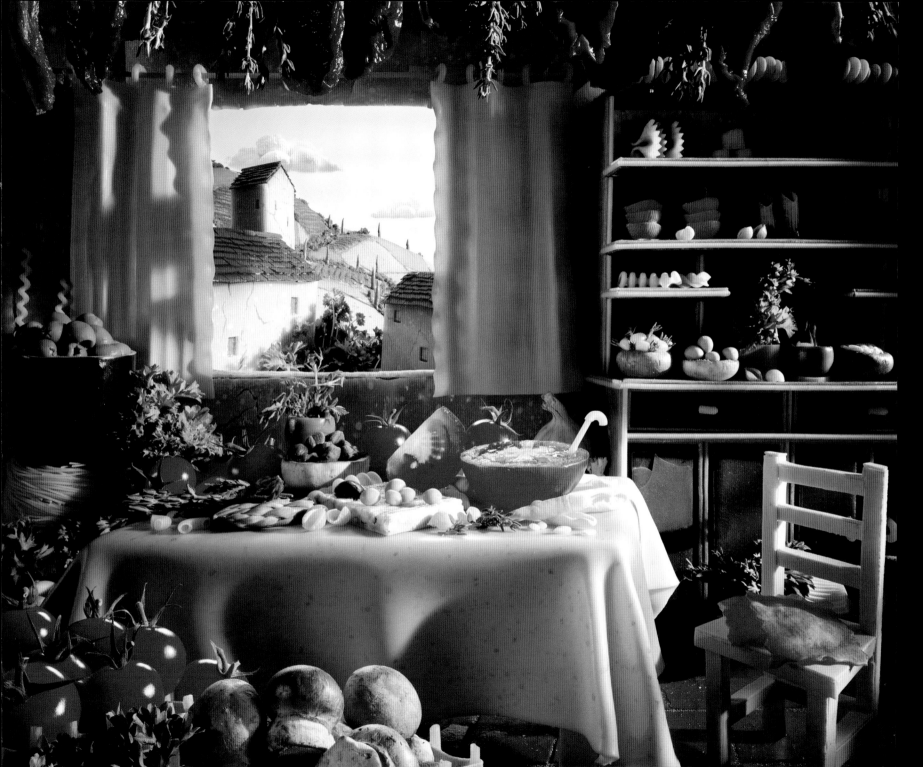

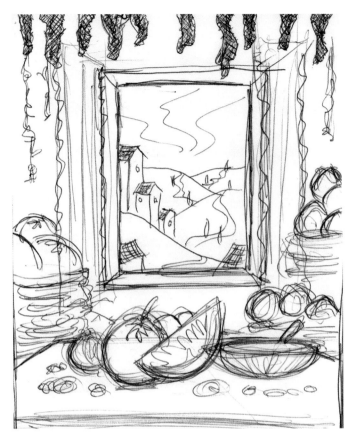

TUSCAN KITCHEN
(Tuscan Triptych Part 3)

Here in the last part of our Tuscan journey we find ourselves in the rustic setting of a Tuscan kitchen bathed in the warm light of the evening sun. With its Parmesan walls and lasagna curtains, the kitchen boasts a pasta dresser upon which we see the vase of parsley that was glimpsed through the windows at the market square. Sun-dried tomatoes hang from the ceiling like cured meats and a piece of freshly rolled pasta hangs over the table as a tablecloth, and on top of that are the various ingredients from which the cook is preparing a meal.

I particularly like the marble chopping board, cut from a piece of dolce-latte cheese, whose blue-green marbling echoes the natural formations that relate to both stone and cheese. As marble is used so extensively in both Italian architecture and sculpture, I am sure that dolcelatte is an ingredient I will use again in the creation of other classical Italian scenes.

I am a great believer in happy accidents, so when something goes wrong or gets damaged during the assembly stages of the scenes, it's not always such a disaster. Here, for example, we see that one of the doors of the dresser was damaged during the shoot (wasn't me!), but the cracking of the dried pasta sheet of the cupboard door makes it somewhat more realistic, and I like the fact that imperfections in objects make them more genuine and characterful . . . a bit like people, really.

Finally, as we look out of the window, we see over the pasta-tiled roofs of our hilltop village to another hill beyond, where our journey comes full circle. This distant hill is actually the hill from the set of the first image, which has been turned and redressed—as I always try to reuse or recycle the models and imagery as much as I can wherever it is possible to save on time and waste.

Sadly, these were the last of the food landscapes to be shot on 10 x 8 film, and I say sadly because the quality of the image achieved on a 10 x 8 transparency using a traditional plate camera is far superior to that from any of the digital backs available today. Shooting at f45 and f64 on a 10 x 8 camera gave me the most incredible depth of field, tonal

Above: Two Polaroids of the undressed scene.
Far Left: A rough sketch of the kitchen-window view.

range, and sharpness that cannot yet be achieved with modern digital technology, and I doubt whether it ever will, as it would be so expensive to develop such a thing for a small market such as myself.

Digital image making does have its plus points, of course, in that you can instantly see what you have shot and are able to work much faster, which is a great asset when working with perishables. There are also marvelous pieces of software that will stitch together multiple-focus images in order to regain that precious depth of focus, and finally, it is a lot more cost-effective to shoot digitally than on film, which enables me to experiment with many

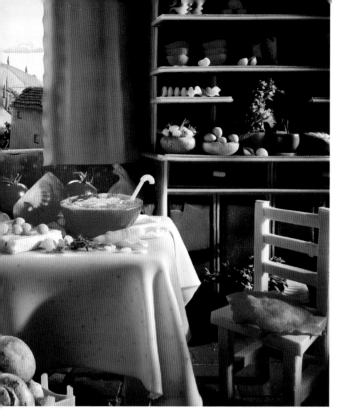

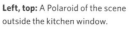

Left, top: A Polaroid of the scene outside the kitchen window.

Left, bottom: The view from the kitchen window.

Far Left: A close-up of the table and the dresser with its broken door.

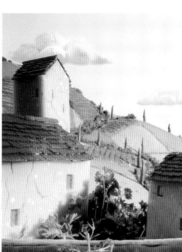

INGREDIENTS

Outside – *mozzarella clouds, fresh pasta fields, green chili cypress trees, parsley hedging and crops, Parmesan buildings, red pasta roofs, parsley trees*

Interior wall – *Parmesan*

Curtains – *dried lasagna*

Curtain pole – *spaghetti with pasta hoops*

Hanging food – *sun-dried tomatoes and oregano*

Dresser and chair – *dried pasta (lasagna verde, spaghetti, tagliatelle, fusilli bucati), ravioli cushions*

Dresser – *decorated with mushroom bowls, olive bowls, conchiglie bowls, farfalle, gomito macaroni, rigatoni, with peas, sweet corn, parsley*

Flooring – *red lasagna*

Baskets and barrels – *linguine nests, fettuccine, tagliatelle, eggplant, filled with button mushrooms, cherry tomatoes, olives, and parsley*

Tablecloth – *fresh lasagna pasta*

Table contents – *dolcelatte chopping board, asparagus, peas, tomato, mushroom bowl with capers, olive vase with oregano, olives, cherry tomatoes, mezzani pasta, conchiglie pasta, spaghetti, oregano*

variations of ingredients and compositions during shoots, which in turn gives me greater flexibility and choice during the postproduction stage of the work.

Having said this, I still feel a certain amount of nostalgic fondness for the discipline and craft that working with film and Polaroid entailed, and so these three images will always remain very precious to me as a reminder of that era, which photography has lost to all but a few remaining stalwarts who admirably refuse to let go.

This series is also of particular significance as it was the first commission I had for the food landscapes since the campaign for Finland several years earlier. If this had not happened, I'm

not sure whether I would have continued to make them under my own steam, as they were always very expensive to produce, so I tended to rely on the advertising commissions to fund the work. This series was commissioned by an Italian pasta sauce company, and as anyone knows who has met an Italian, they are very passionate about their country and their food (not to mention their soccer), so for me as an Englishman to capture the essence and passion of their gastronomic heritage was quite a tall order. As a campaign the landscapes also needed to stand up on their own as individual images, so again this was a challenge to make all three pictures work with equal strength, as often a

series will have stronger and weaker imagery.

This series was also a major turning point for me, as not only did I love doing them, but their success gave me the confidence to move forward in developing the craft further, and the enthusiasm and energy to want to create more.

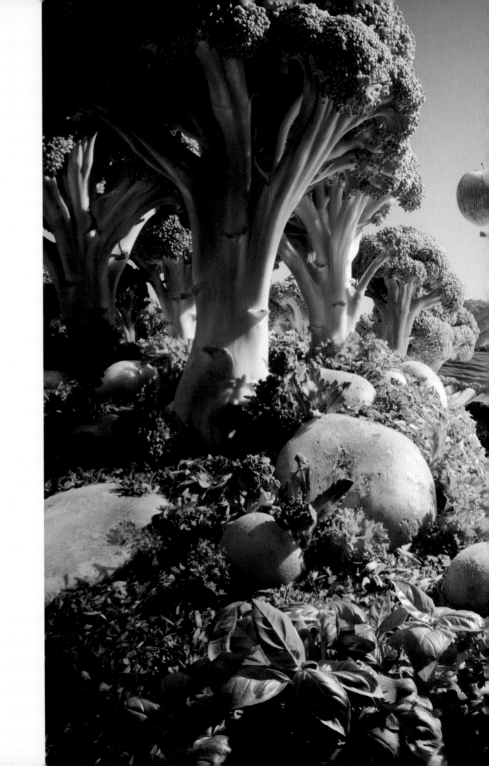

Cart & Balloons

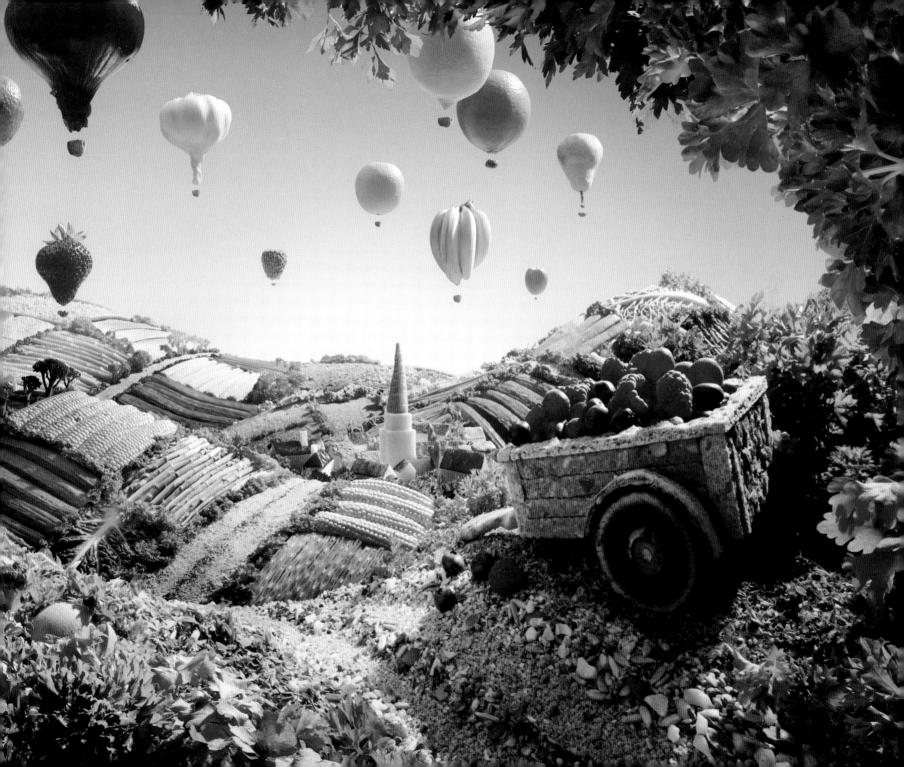

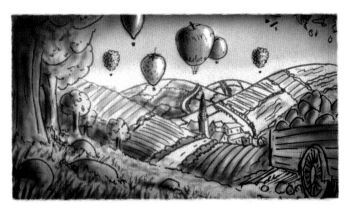

Above: The revised sketch for the client.

Below: A close-up of the cart and cheddar cheese village (whose red roofs are made from red apple skins).

Opposite: A detail of the balloons floating above the crops.

CART & BALLOONS

This has to be one of the most successful and popular images of the collection. It is certainly one of the longest and most labor-intensive shoots I have done, due to the level of detail and the time-consuming complexity of the build.

This image began life as a commission for one of the major supermarkets in the United Kingdom, which wanted to promote its organic range of fruit and vegetables. Having produced quite a few scenes involving vegetables, I was confident of being able to use herbs and broccoli trees, and I soon realized that an agricultural landscape using repetitious lines of things like baby corncobs and runner beans could be used to give a patchwork of farmed fields across the rolling hills of my countryside scene.

The big problem lay with fruit, and I guess it will always be a problem for me in trying to include fruit in scenes, as most of it is round and brightly colored, so it doesn't resemble the natural formations or colors of a landscape. This was a really big problem, as I was never going to get the commission from the client or the agency unless I could give equal weight in the image to both the fruit and the vegetables.

My solution was to put summer fruits such as berries and soft fruits into a cart, similar to the way in which I had used the garlic bulbs in the Tuscan landscape, but this meant that only a few could be featured, as the cart would only take up a small part of the picture. However, as it was close up to the camera in pride of place, I was hopeful that its prominence would be enough to redress the balance and secure the commission.

Sadly, my hopes were dashed as the multitude of vegetables within the scene showed an amplitude of range of which my

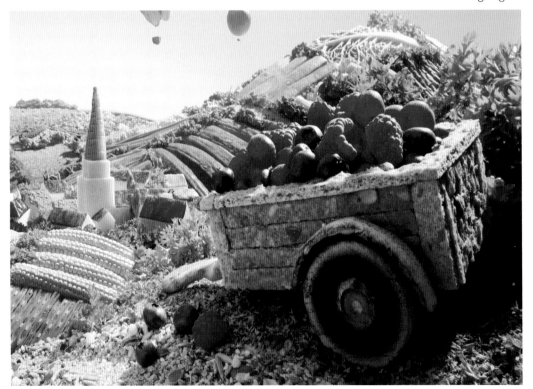

sad cart was falling way short, and this was all becoming clear during a meeting at the advertising agency, where I felt like a decorator who had shown up without enough paint.

Squeezing my eyes with thumb and forefinger, I sat back in my chair trying to ignore the fact that this commission would please my bank manager as well as my wife plus four children, and looked to the big guy upstairs for a flash of inspiration. As I did this, I became incredibly relaxed and almost floated above the corporate gathering, feeling totally exposed as the absolute busker I am, but finding it quite funny at the same time.

As I looked down at the drawing in front of me that I was presenting, I saw the empty sky filled with balloons as it is on sunny Sunday mornings and late afternoons when the air is cool in the countryside where I live. "Why don't we make fruit into hot-air balloons?" I blurted out, and quickly scribbled a few onto the drawing to show what I meant. "Their shapes and colors work perfectly and they don't need to adhere to the organic structure of the land-scape." There was a brief silence before the stalemate atmosphere was washed away by the exhalation of lungs and the sanctuary of benevolent smiles.

Phew . . . the busker returns!

INGREDIENTS

Balloons – red onion, apple, avocado, strawberry, garlic bulb, raspberry, orange, lemon, lime, pear, bananas

Balloon baskets – almonds, walnuts

Hills and fields – bread, cucumbers, string beans, green beans, sweet corn, baby corn, asparagus, cabbage leaves

Hedges – parsley

Village – cheese buildings, apple-skin roofs, mushroom roofs, carrot church spire

Trees and foliage – broccoli, parsley, basil, purple sprouting broccoli, chopped herbs

Road and rocks – potatoes, buckwheat, oatmeal, various seeds such as sunflower and pumpkin seeds

Cart – spelt crackers, mushroom wheel and mudguard, cheese swirl

In the cart – raspberries, blueberries, red grapes, red currants

Polystyrene hills carved with hot wires and painstakingly covered inch by inch with fields and hedgerows, were lovingly assembled in the studio. Piece by piece, the foreground, middle ground, and distant hills were plotted, plowed, and planted in front of the camera to build this traditional countryside view where hot-air fruit balloons drift silently by on wires that were later removed.

One of my favorite details is that the red roofs of the cheddar cheese village are made from red apple skins. It's some-thing few people would know, guess at, or even recognize, and for Paul the model maker, this has remained a quiet bit of in-the-know that only he and I appreciated . . . until now!

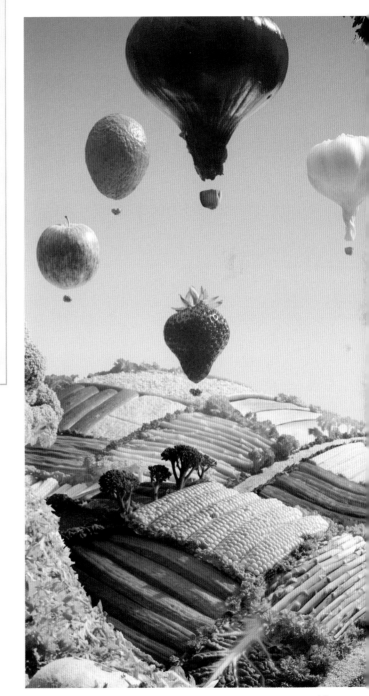

Breadford & Cheesedale

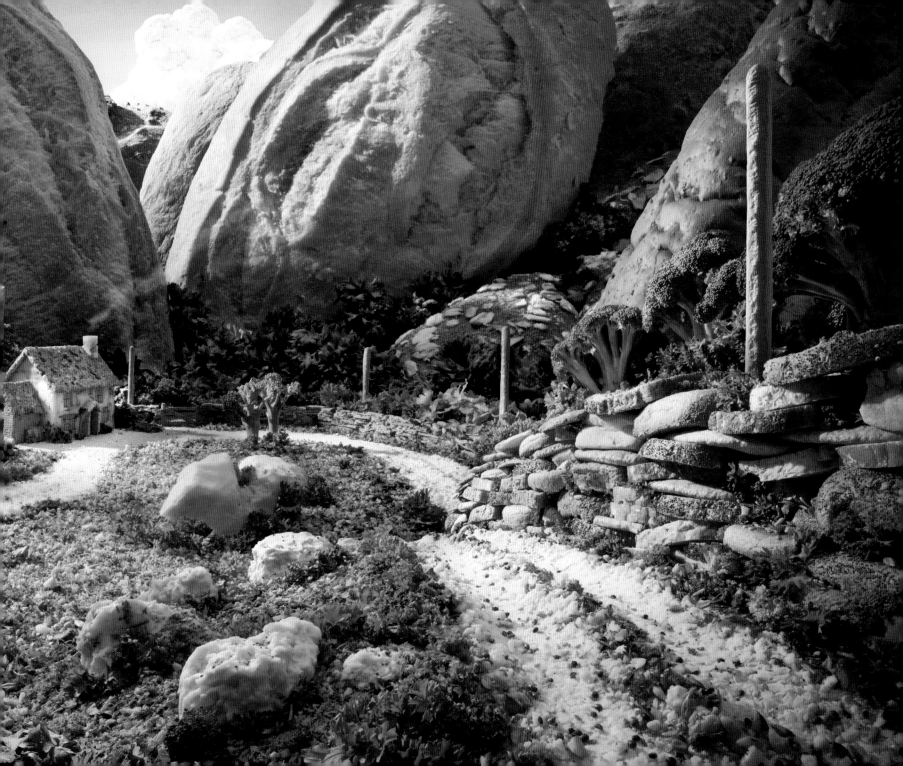

BREADFORD & CHEESEDALE

Right: A detail of the Stilton farmhouse.

Below: The middle ground set ready to shoot.

Opposite, left: An aerial view of the farmhouse.

Opposite, right: Adding the final sprinkles of parsley.

The Cheddar Gorge is a limestone gorge situated near the village of Cheddar in Somerset, England. It's a popular tourist destination, and as cheddar is the name of a very popular cheese, most children who visit there think that the gorge is in fact made of cheese, and when they realize that it is not, they are usually very disappointed. Still, at least the moon is made of cheese!

The idea of a land made of food is a very attractive one to the young mind, and mine has been no exception. But whereas most children would want to visit a land made of sweets or chocolate, I believe that the older minds with less of a sweet tooth and a more mature palate would prefer something a little more savory.

INGREDIENTS

Dry stone wall – mixed sliced bread
Background rocks and mountains – large crusty white bread
Foreground rocks – cheddar and stilton cheese
Roadway – crumbly white Cheshire cheese
Ground cover – chopped parsley, broccoli heads
Cart – spelt crackers with biscuit wheel, filled with red and white grapes
Telegraph poles – breadsticks
Farmhouse – Stilton cheese, crackers
Logs – asparagus
Trees – broccoli
Clouds – cauliflower

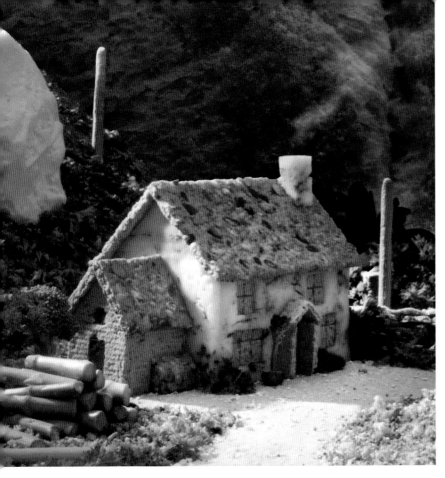

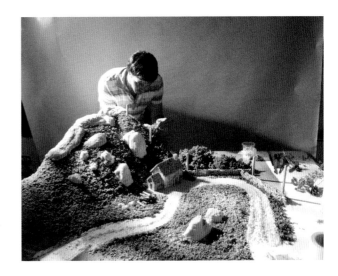

Commissioned by a large U.K. supermarket, the brief for this food landscape was that it should be made of mainly bread and cheese, and as I knew that crusty bread and broken pieces of cheese made for great rocks and mountains, it was clear to me that this would not be too difficult to make work. What I needed, though, were some key focal points within the picture with which to lead the viewer's eye.

The first thing I thought of was the sliced bread wall. This was something I'd had in mind for some time, as I love the old dry stone walls that line the country lanes and fields throughout many parts of the United Kingdom. The different colors and textures of whole wheat, seeded, and granary loaves all look like slabs of stone when viewed on their ends, so stacking them in a loose random pattern quickly gave them the appearance of dry stone walls.

The second idea that came to mind was to make a farmhouse, as the word "farmhouse" is used in the description of many English cheeses, so making one out of cheese seemed like an obvious thing to do. This particular one was made from Stilton, as the blue veins in the cheese gave the appearance of cracks or ivy on the exterior walls. With the addition of spelt crackers for the roof, doorways, and windows as well as a small outbuilding on the side, the block of cheese made for an idyllic country farmhouse.

The third idea was to include some grapes in the scene, as we often eat grapes with cheese and biscuits as a sweet accompaniment to the savory taste, and they also add a bit of color, which is an attractive decoration to any cheese board or platter. The best way to present them in the shot was, I thought, in a wooden cart, which we made from more spelt crackers

45

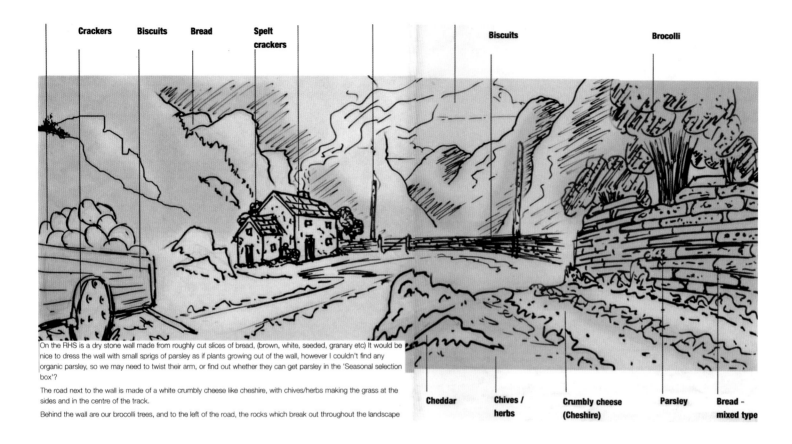

Crackers | Biscuits | Bread | Spelt crackers | Biscuits | Brocolli

On the RHS is a dry stone wall made from roughly cut slices of bread, (brown, white, seeded, granary etc) It would be nice to dress the wall with small sprigs of parsley as if plants growing out of the wall, however I couldn't find any organic parsley, so we may need to twist their arm, or find out whether they can get parsley in the 'Seasonal selection box'?

The road next to the wall is made of a white crumbly cheese like cheshire, with chives/herbs making the grass at the sides and in the centre of the track.

Behind the wall are our brocolli trees, and to the left of the road, the rocks which break out throughout the landscape

Cheddar | Chives / herbs | Crumbly cheese (Cheshire) | Parsley | Bread – mixed type

and a wonderful digestive biscuit for the wheel, which had a hazelnut hubcap.

It was important for the client that I include as many different cheeses as possible, but as I was using them for rocks, it made it hard for me to use some of the softer cheeses, so we ended up using the three most popular English cheeses—cheddar and Stilton for the rocks and a crumbly Cheshire cheese for the dirt track road which, after being dressed with nuts, seeds, and a little parsley, worked very effectively in leading the viewer around the farm.

The longest and most boring part of making this scene was the endless chopping of broccoli heads and parsley for the ground cover, but the hard work does pay off when you see the set fully dressed with the full leaves of fresh herbs. With the final addition of breadstick telegraph poles and broccoli trees to help enhance the perspective, and the cauliflower clouds to once again add depth, scale, and distance to the vista, the image was complete. Though a glass of red wine wouldn't have gone amiss!

Above: The original annotated layout that I presented to the client, with a description of the scene and the ingredients.

Right: Dressing the set and planting the broccoli trees.

Opposite: The dry stone wall made

46

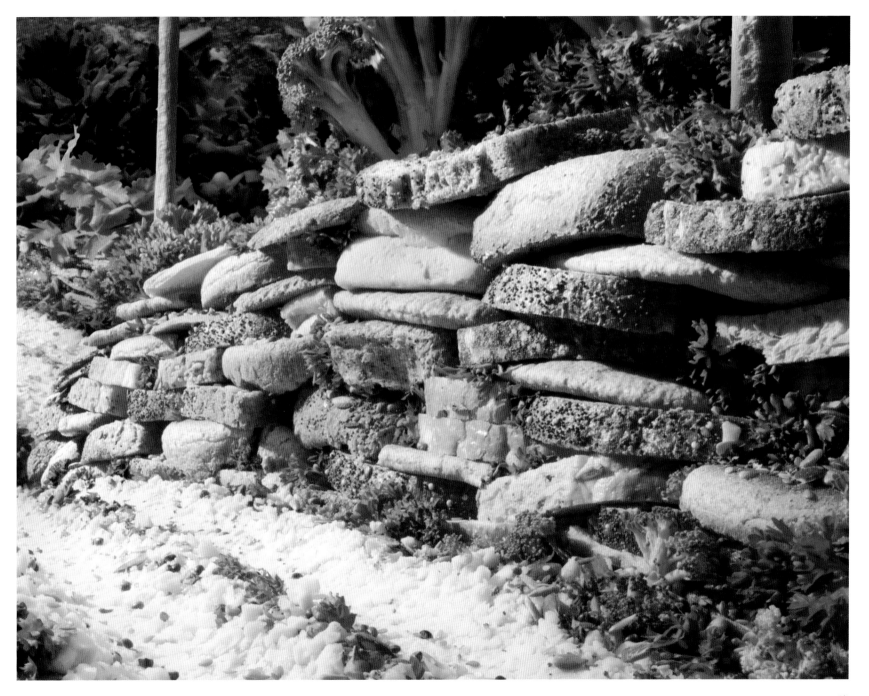

47

Raspberry River

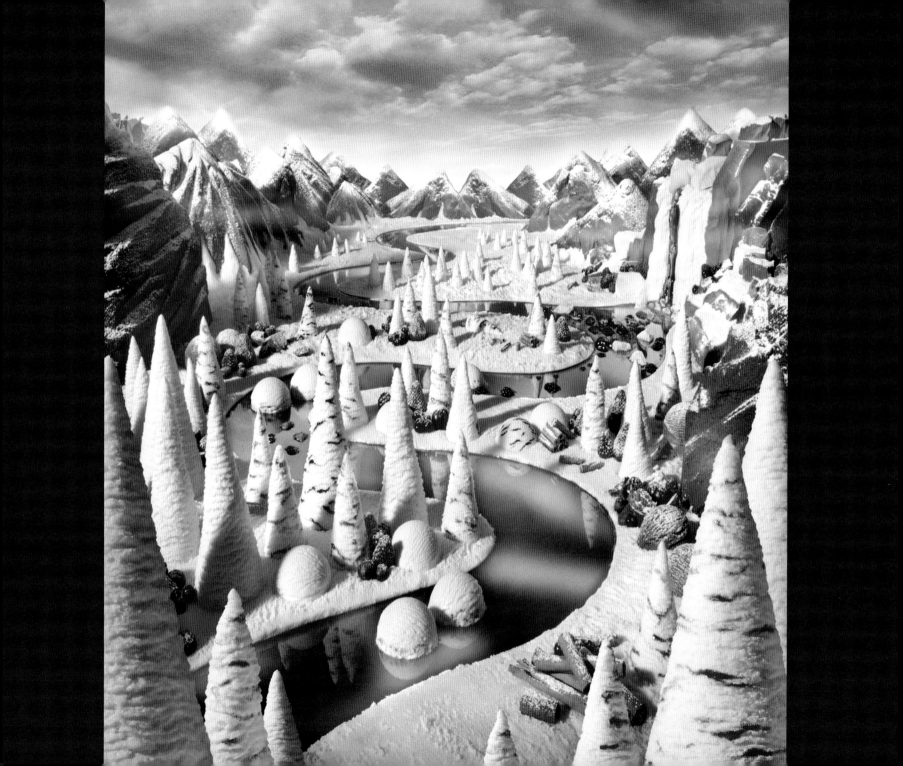

RASPBERRY RIVER

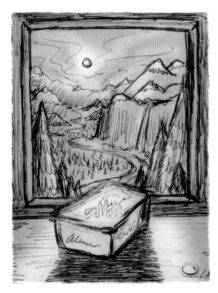

A sketch of the scene through a window frame, with the ice cream pack in the foreground.

As awareness and popularity of the food landscapes increased in the public domain as well as within the advertising industry, I began to get requests from agencies about taking the work into the wonderful world of the moving image. The first of these came from an agency in Romania that wanted to make some TV commercials for their client's brand of ice cream. Having never directed before, I made it clear to them that this would be my debut, but that I was keen to try, as this was a great opportunity to bring my imagery to life in this way.

Thankfully, Paul the model maker had a lot of TV experience under his belt and together with a wonderful director of photography, John Ignatius, who took me under his wing and showed me the ropes, we flew out to Bucharest to do the shoot.

On the first day I was quite taken aback by the sheer scale of a TV shoot. My London studio seemed like a shoebox compared to this enormous aircraft hangar, which echoed with the sounds of so many people and so much equipment that I thought there was some kind of mix-up with a much bigger shoot. Truckloads of lights, stands, tracks, dollies, monitors, and generators came pouring in to fill the space, and before I knew it, there were enough cables snaking across the floor to make Indiana Jones a nervous wreck.

At this point I was feeling incredibly apprehensive but extremely excited at the same time. As I wandered around watching this army of people all busy doing things, I felt like a fifth wheel, which was very frustrating. John was the director of photography, so I couldn't even set up a camera or play with the lights without someone rushing to take it off me. My role as director was to make sure the magic was delivered to the client, as all things technical were taken care of by the crew, who was there to help me make this happen. I felt like a bogus doctor who had to deliver a baby; the studio was the hospital, the crew were the nurses, and the client and agency were the expectant mother and father to be. So no pressure at all!

Once the stage was built and all the lights in place, I found myself in the familiar place of assembling a scene in front of the camera, with Paul and his assistant, Neil, placing ice cream trees into a snow-covered valley of fondant icing. This was the part I knew well, and once I got the hang of looking at everything through a camera that traveled through the landscape instead of being locked down, I found it easy to see how it was all going to work.

One of the biggest problems we faced was that of the sky. You need so much more with a moving image, as the wide-angled lens will reveal studio and lights at the slightest turn, which of course is not an issue when shooting from a static viewpoint. On this job, however, there was another problem with the sky. I had sent the Romanian production company a rough sketch of how I wanted their scenic artist to

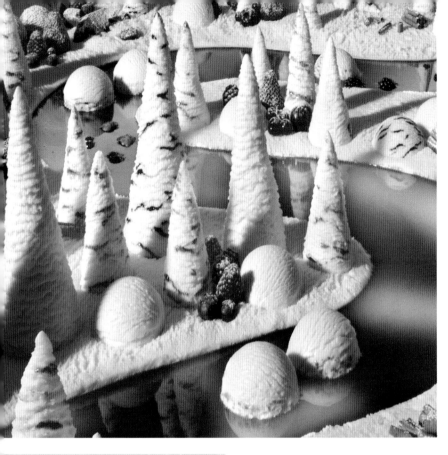

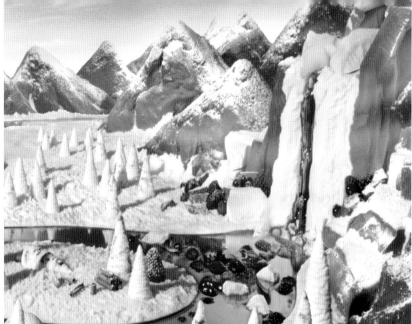

Above: A detail of the raspberry waterfall.

Left: A close-up of the ice cream trees and rocks, which are reflected in the raspberry river.

INGREDIENTS

River and waterfall – *raspberry sauce*

Mountains – *chocolate cake with icing sugar snowcaps*

Rocks – *milk, white, and dark chocolate*

Logs – *cinnamon sticks*

Landscape – *fondant icing*

Trees and snow-covered boulders – *vanilla ice cream with strawberry, cherry, and raspberry veins*

paint cloud formations. It was just a rough guide that would allow the artist the creative freedom to do what he wanted, as long as the basic composition was adhered to. Unfortunately, there was not enough budget for a scenic artist and so they had printed my sketch onto a twenty-by-forty-foot canvas, which, to my horror, was unraveled before me and mounted on a large frame at the back of the set. That large, it looked like a child's scribbling. Thankfully, they were able to drop in a real sky in postproduction, to my great relief.

After the filming was finished I had a few minutes to set up my stills camera and take a shot of the scene for the press ad. The raspberry waterfall trickled over the chocolate rocks, raspberries and strawberries bobbed about in the river, and the cold dry ice gently misted the valley floor. There was a strange silence as everyone observed the peaceful art of the stills photographer at work, and as I stared through the lens at this exquisite landscape, I couldn't help but think that this world of ice cream was a lot more peaceful and less insane than the crazy world of TV advertising that had helped to create it. So I lingered a little longer, before finally saying those famous words "It's a wrap," after which the place was torn apart, and within an hour or so, the empty aircraft hangar reappeared as all the magic disappeared.

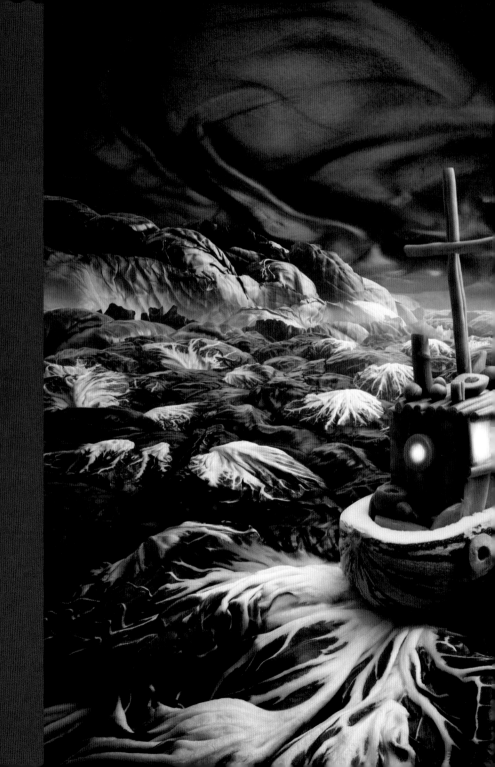

Cabbage Sea

CABBAGE SEA

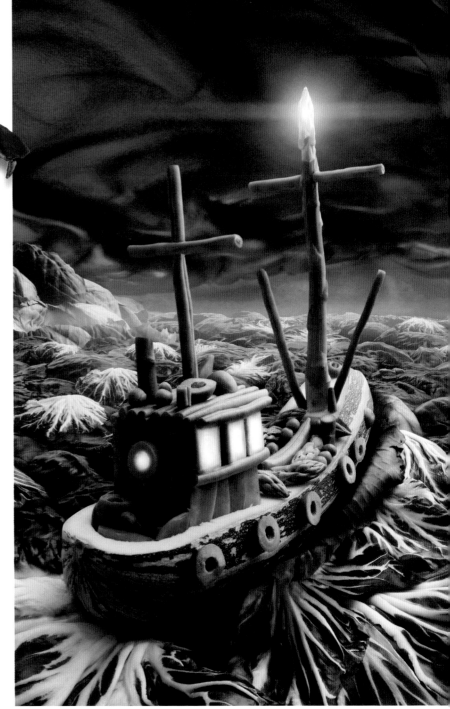

This is by far one of my favorite images of the collection, partly because I made it all by myself (which strikes fear in my team of helpers and keeps them on their toes), and partly because the whole thing happened by accident.

Having just been commissioned to produce the Swedish fishscape (see page 56), I decided to have a go at building the prototype for the fishing boats that would be featured in that image to see how it might be constructed, and how it might look in terms of angle and lighting. After buying a selection of small marrows, asparagus, mange-tout (young peas in the pod), and green beans from London's famous Borough Market, which is close to my studio, I headed back to the workbench to begin making my boat. After about an hour of cutting and pinning the various green vegetables, my simple marrow boat was complete.

I was so proud of my efforts and the fact that I hadn't called upon my trusty model maker, Paul, that I decided to take a shot of it to show him how capable I was of making my own food models and, contrary to popular belief, not just someone who just sits behind a camera telling people what to do. Realizing that I needed to create some kind of water to sit the boat on, I raced back to the market to look for some green cabbage leaves with which to surround the vessel so that the boat could be seen in the right context. While searching through a pile of green cabbage leaves I noticed the dark shiny purple spheres of red cabbages and thought that their color would be much more of a contrast to the green boat. As I piled a few of these into my basket, I also noticed some purple radicchio and threw a few of them into the basket for good measure.

Back at the studio things started to get very exciting, and a quick snap to show Paul what a clever lad I was began to turn into a fully fledged work of its own. Not only did the red cabbage leaves take on the appearance of dark water and wet rocks, but the radicchio leaves instantly took the form of the foamy peaks of a turgid sea, and not only that, its white veins made for the perfect wash in the wake of the boat. I could hardly contain my excitement and I was alone in the studio with no one with whom to share this amazing discovery. Telling my wife over the phone just wasn't cutting it; you needed to see with your own eyes that cabbages could look like a dark and stormy sea at night.

Having laid the whole seascape out on the tabletop and lit the scene as if bathed in moonlight, I still needed a destination or other element in the shot for the boat to be traveling toward. My first thought was for some distant harbor lights and the safety of a port in a storm, and then it dawned on me: a lighthouse! A beacon of light guiding our brave fishermen away from the rocks and safely home in time for a "fish and chip" supper. So back down to the market I went for a large courgette (zucchini), and together with some of the leftover marrows for the rocks around its base, the cabbage seascape was almost complete.

Many of the skies I use in my work are shots I have taken of real skies and then printed on large canvases, which are hung at the back of the studio, but wherever possible I like to make the skies out of food as well so that the whole

image is made from edible ingredients. In this instance it was easy to see that the close-up textures and forms within the red cabbages resembled the swollen clouds of a dark, stormy sky, so I shot these separately to drop into the image at the retouching stage. The final touches of light beams from the lighthouse and turning the top of the asparagus mast into a navigation lantern gave the image some more focal points of light with which to anchor the final composition.

Although some people tend to favor the brighter, more colorful images I make and find this particular scene less appealing due to its dark and ominous nature, I have to say that I love its mood and atmosphere as well as it being a visual metaphor of hope.

Above: The zucchini lighthouse.

Below: The guide sketch I made for the retoucher after shooting the scene.

Opposite: A close-up of the fishing boat; the navigational lantern at the top of the asparagus mast was a final touch.

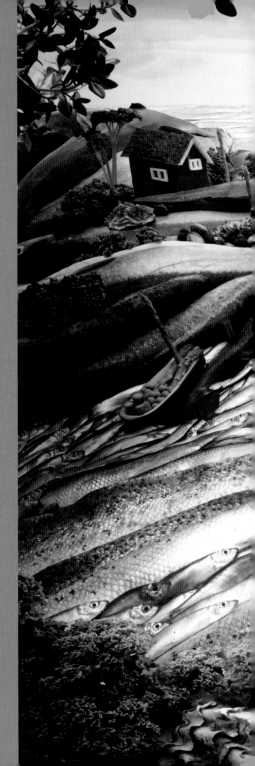

Fishscape

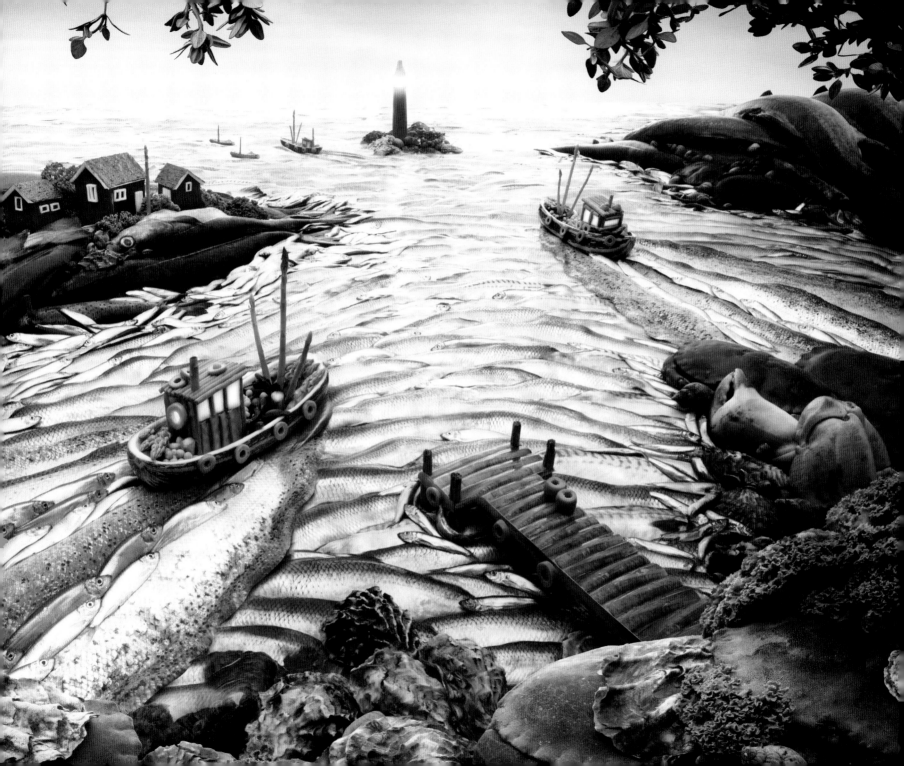

INGREDIENTS

Foreground trees – sprigs of thyme

Foreground rocks – lobster, crabs, oysters, mussels, cockles, whelks, scallops

Foreground plants – curly kale

Jetty – razor clams, cinnamon-stick posts, olives

Middle ground land masses – pollack, coley

Fishing huts – red peppers, seaweed roofs

Telegraph poles – asparagus

Bushes – curly kale

Fishing boats – marrow hulls, mange-tout and green bean cabins, asparagus masts

Cargo – seaweed, asparagus heads, sugar snap peas

Buffers and life preservers – olives

Windows – potato slices

Wakes of boats – sides of salmon, sprats

Sea – sea bass, herring, mackerel, sprats, white bait

Lighthouse – courgette (zucchinis) with marrow and oyster shell rocks

Just off the coast of Sweden lie archipelagos, clusters of small islands where smooth dark rocks huddle together like schools of sleeping whales. Clinging to these rocks are jetties and bright red fishing huts that house the local fishing communities, and these were the references I looked to when commissioned to make a foodscape, or in this instance a "fishscape," for a Swedish fish and seafood company.

I love to find the small things in the natural world that look like their larger counterparts. It alludes to the idea of implied design, which I find both fascinating and intriguing, as it highlights a connection with organic matter where, I believe, we find "God in the details." Here, for example, I found it challenging to see whether I could make the ocean out of fish.

Following the success of the Salmon Sea, in which the texture of the smoked salmon looked amazingly like the eddies and currents we see on the surface of large bodies of water, I hoped that the shiny scales of silver fish would reflect the sky, and that their bodies could be arranged so as to give the impression of waves and wakes. So after providing the client with a series of drawings, we decided upon a mixture of two of the sketches on which to base the scene, and having set a date, we began to plan the shoot.

Carl and Neil working on the salmon wake.

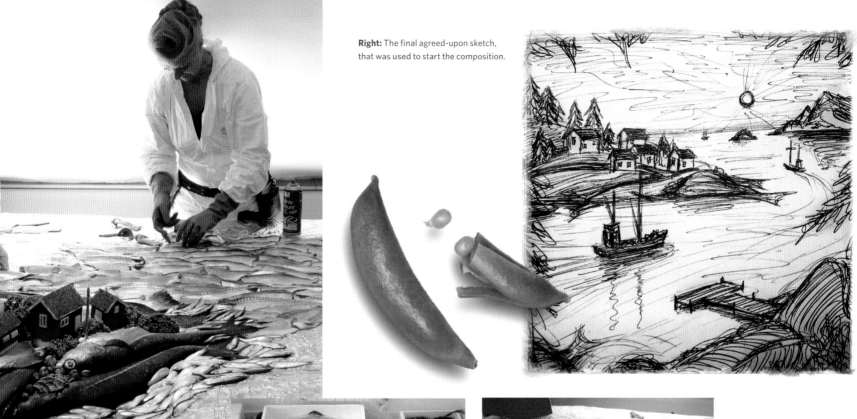

Right: The final agreed-upon sketch, that was used to start the composition.

Above: Neil and Peta laying out the fish to form the distant sea.

Right: Fish boxes delivered from the Billingsgate fish market.

Far Right: An aerial view of the scene.

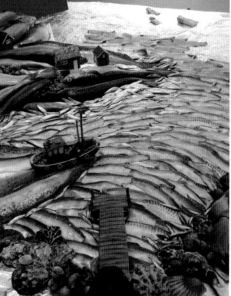

It was important to get a good contrast and distinction between the land and the sea, so we used darker-skinned fish such as pollack or coley for the islands, and lighter, more silvery fish such as herring and sea bass to represent the sea.

At 5:00 A.M. one cold February morning, my food stylist Peta wandered bleary-eyed through the Billingsgate fish market in London, gathering over fifteen hundred pounds (Sterling, or over two thousand dollars) of fresh fish and seafood for a mad photographer who was looking to re-create the Swedish coastline in his studio. Not an easy thing to explain to a fishmonger at 5:00 A.M., but a great way to raise his eyebrows!

A few hours later, our silvery friends were being unloaded at my studio in large ice-packed polystyrene boxes. Sheets of plastic and silver foil were laid onto my large triangular tabletop, and team members were suiting up in white overalls and rubber gloves so that their loved ones would not banish them to the spare room for the next few nights because of the smell.

While model-maker Paul began cutting up razor clams on his mini jigsaw cutter to make the jetty (which took most of the day to accomplish), I began directing the rest of the team as to where to place the darker fish,

so as to fit with the composition on the drawing of where the land and rocks should be placed. There is no exact science to this process; we just throw something on the table and then it is a simple case of either "Yes that works" or "No that looks terrible." Occasionally when something feels right but doesn't look good, it is usually a case of turning, flipping, or rotating something in order to get it to work for the shot.

It was approaching midnight by the time we were near ready to shoot. The painstaking placement of sprats and whitebait around the rocks and boats, the hours of overlaying herring, sea bass, and mackerel while tucking in their tails, was all starting to pay off. Model-maker Neil had followed the design of the boats I had made for the Cabbage Sea, and Peta cut whole sides of salmon for the wakes, which she placed skin side up, then dressed with the beautiful silver sprats. We used red peppers for the walls of those typical red fishing huts, and sheets of dried sushi seaweed for their mossy roofs. As Paul finally finished his awesome razor clam jetty and the last few squirts of water were sprayed onto the now somewhat stiff and pungent scene, I fired the shutter to capture what is probably my favorite image of the series so far.

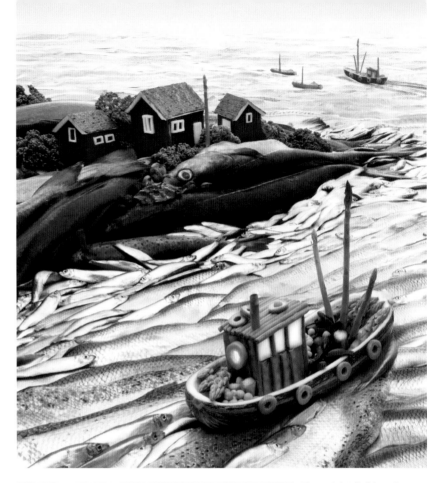

Above: A detail of the red-pepper fishing huts (with roofs of sheets of dried nori) and boats.

Left: Pier detail showing razor clams with sliced olives as tires.

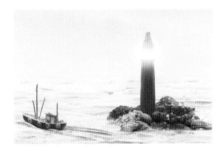

On the late train home I was aware of some strange looks from my fellow passengers, and it wasn't until I got into the car with my son, who had kindly picked me up from the station in the early hours, that I was made aware of how bad I smelled! As he drove most of the way home with his head out of the window, braving the cold night air, I reflected on the beautiful Nordic scene of marrow boats heading out into a sea of silver scales in the early-morning light, as well as the blessing that having no sense of smell can sometimes be. However, as someone who loves and works so closely with food, I find it increasingly saddening that this sensory enjoyment is something that I may never experience again, though I have to say I wouldn't want to swap it for any of the other four senses in order to get it back again.

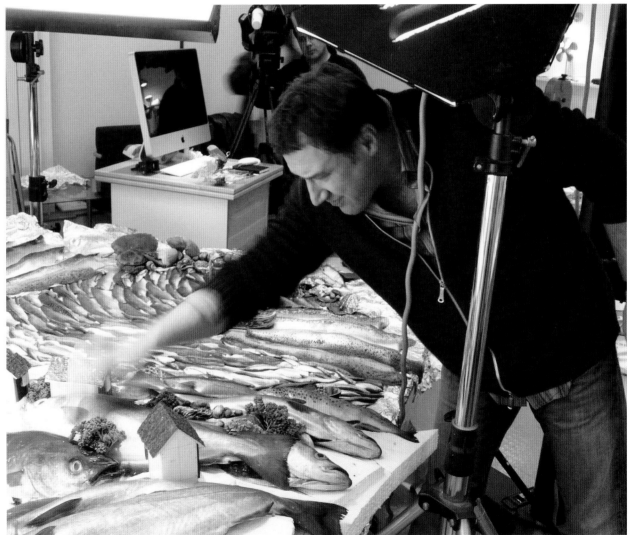

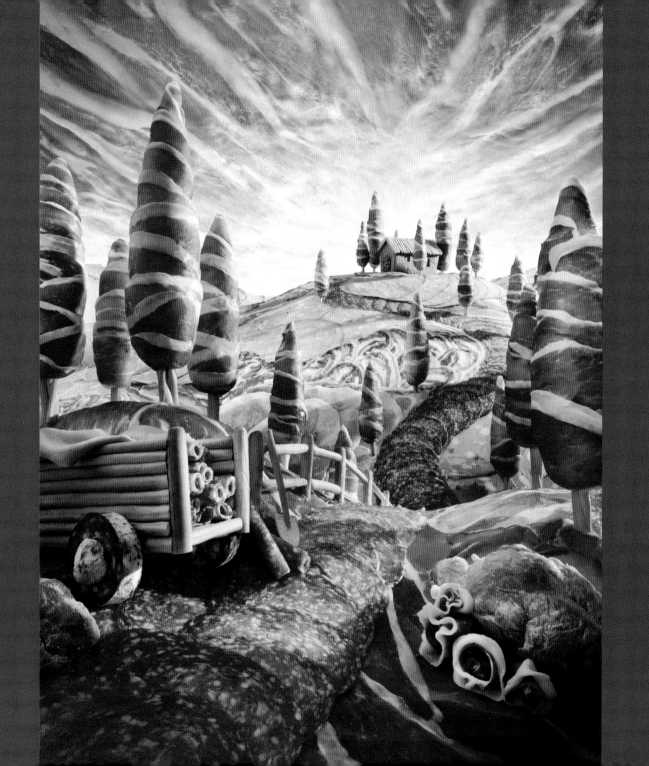

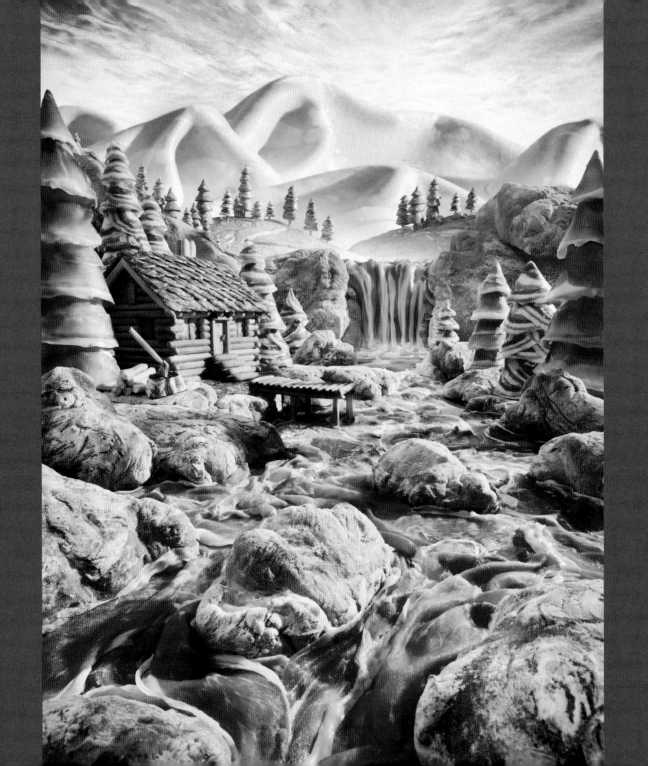

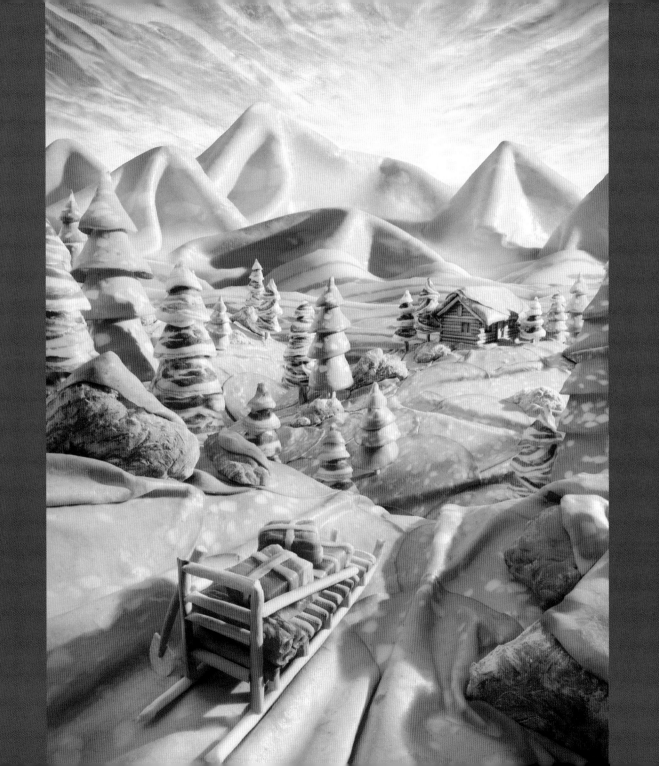

SALAMISCAPES

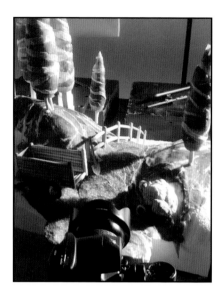

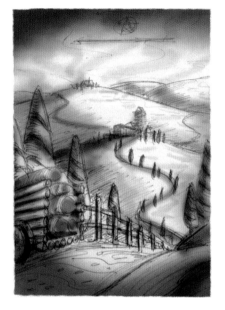

Probably one of the bravest decisions I have ever made was to take on this brief from an Italian ad agency for their client Negroni, which specializes in cured meats, or *salumi*, as they like to call it. They wanted to commission a campaign of three images but using only the cold cuts they produce, and as they wanted no other ingredient in the shots, my first thought was that this would be impossible.

The art director, bless his heart, had produced some visuals that he had created himself using his own camera and a pile of different hams and salamis. These were a little childlike in their construction and composition, but I could see where he was going with it, and as he had included some breadsticks, I wondered if I could push that door open a little further to include other types of bread, and especially ciabatta bread, which I knew would provide some great rocks with which to give the scenes some structure for us to build upon.

Having made some sketches of a typical Tuscan scene, a snowy mountain scene, and a mountain river scene, I began to feel more confident about creating the images, and as the client already liked the visuals that the art director had produced, I knew that these could be easily improved upon, so I agreed to do them.

The first one was quite simply a meaty version of the Tuscan landscape I had made the previous year, a bread loaf Italian villa on a hill with a cypress tree-lined road leading up to it. The foreground was a breadstick fence instead of a wall, and a breadstick cart filled with rolls of salami, which are being used to repair the salami-carpeted road.

The thing that makes this scene so identifiable as Tuscany are the wonderful pointed cypress trees, which were made by wrapping Parma ham around carved shapes of polystyrene with breadstick trunks. The hills were also carved from polystyrene and covered with speck, pancetta, and mortadella to give the appearance of farmed fields.

Finally, the sky was made from Parma ham, which was laid upon a sheet of glass and softened with a bit of blending at the retouching stage.

The three elements of sky, middle ground hills, and foreground road all came together well in postproduction and although I could not use all the things that I know work so well, such as herbs like parsley for plants and vegetation, the landscape was perfectly recognizable, and the monotone aspect of this almost singular color palette seemed to enhance the stylized, illustrative look and feel of the image.

As the composition was pulled together on the screen, my Italian clients applauded and used words like "bravo" and "magnifico," so I thought it best to press on before the hugging and kissing began!

INGREDIENTS

Salami Tuscany

Sky – Parma ham

Cypress trees – Parma ham with breadstick trunks

Road – salami

Fence – breadsticks

Cart – breadsticks with cooked ham rolls inside

Wheel – pepperoni, Italian sausage

Hill – mortadella, cooked ham, speck, pancetta, Parma ham

Villa – loaf of bread with breadstick roof

Foreground rock – ciabatta bread

Flowers – rolled Parma ham

Salami River

Sky – Parma ham

Mountains – mortadella

Fir trees – wrapped in Parma ham, speck, and pancetta

Rocks – ciabatta bread

River and waterfall – Parma ham

Log cabin and jetty – breadsticks with pepperoni shingle roof

Ax and logs – breadsticks

Salami Mountains

Sky – Parma ham

Mountains – mortadella

Foothills – pancetta

Hills and foreground snow – mortadella

Rocks – ciabatta bread

Trees – mortadella, speck, Parma ham, pancetta

Sleigh – breadsticks with Parma ham parcels

Below, left: A Tuscan farmhouse made from a loaf of bread.

Below, right: Carl focusing for the final shoot.

Bottom: A detail of the salami road repair.

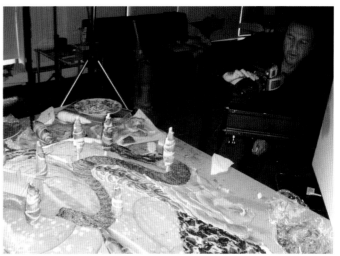

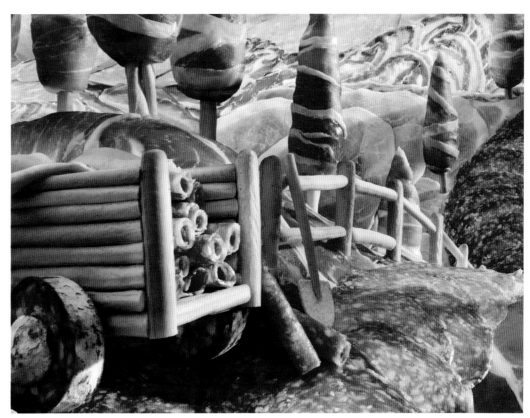

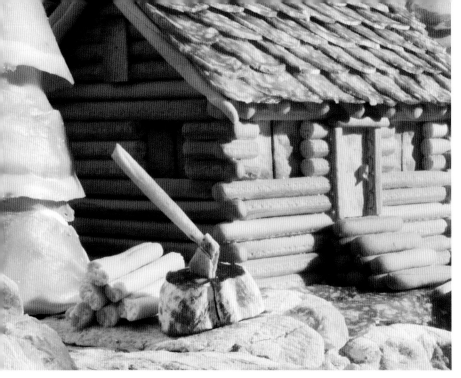

Left: A detail of an ax in a salami tree stump.
Below, left: The final sketch for the client.
Below, right: A close-up of the Parma ham rapids.

Next up was a rocky mountain scene with a river of Parma ham. Out of the three, this one was my favorite, as I loved the way that the Parma ham looked like the tumbling water of a fast-flowing river. Due to its soft and slightly greasy texture, it could be pressed together and molded to make the shapes of ripples in the flowing water, and if a piece wouldn't blend, then out it came to be instantly devoured by the pack of hungry Italians and crew.

A different shape of tree was made for this scene, as the altitude of the location dictated more of a fir tree found in the Dolomites and Alps of northern Italy. Again, these were wrapped in ham and placed throughout the ciabatta rocks. Paul built a wonderful log cabin and jetty out of breadsticks, and small slices of a pepperoni-style Italian sausage were cut to make the shingle roof. One of the sweetest touches was a tree stump made from a chunk of sausage stuck into which was a small ax that the cabin dweller had left. This started the "bravos" off again, so we quickly moved on.

In the distance, we made use of the same sky and made soft snowy mountains from the rather slimy mortadella, which would give us the suggestion of where we were to go next.

The final scene in the campaign was a winter landscape of snow-covered hills and mountains in which we predominantly used the smooth, pink mortadella to create the illusion of soft snowdrifts. The log cabin had its pepperoni roof covered with pink snow and was brought back to live a new life as a wooden hilltop chalet. Trees were also rescued and redressed from the river scene, and the carved hill from the Tuscan set was re-covered with more mortadella to build the alpine vista. The sky and distant mountains were added together with a foreground sleigh, which was again made from breadsticks and carried small meaty parcels as presents for the chalet dwellers.

Out of the three, this has been the most popular scene, as I suppose the look of snow made it a little more convincing than the other two, which softened these vegetarian nightmares into something a little more dreamy. As we viewed each image side by side, my charming Italian friends seemed as delighted as they were when they won the World Cup! . . . Well, almost.

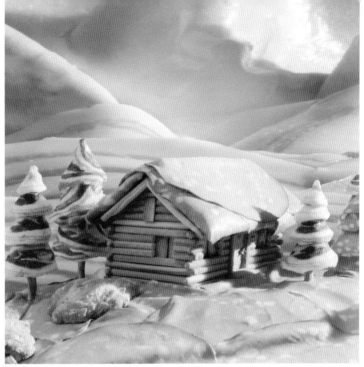

Top, left: An early sketch showing the snowy mountain scene.

Top, right: The log cabin from the river scene reused here as a mountain chalet.

Bottom, left: A detail of the Parma ham parcels on the sleigh.

Bottom, right: The foreground elements dressed and ready to shoot.

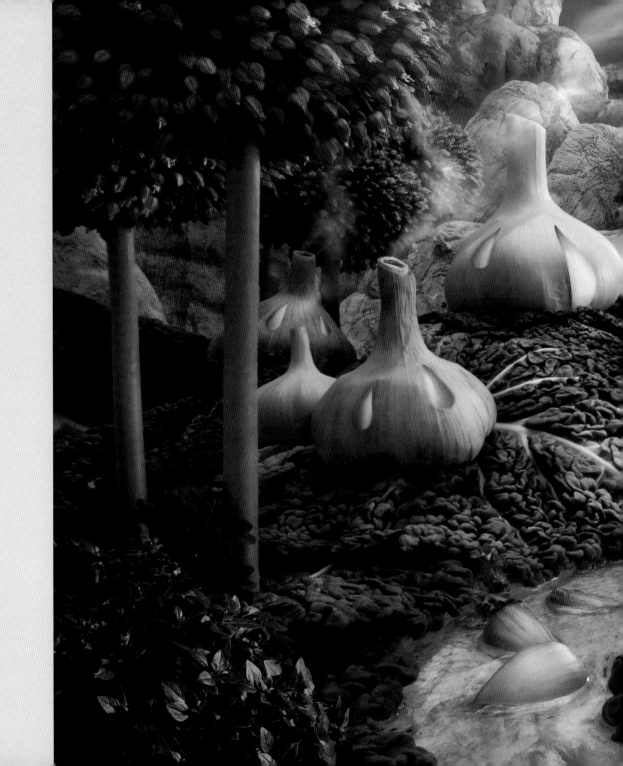

Garlicshire

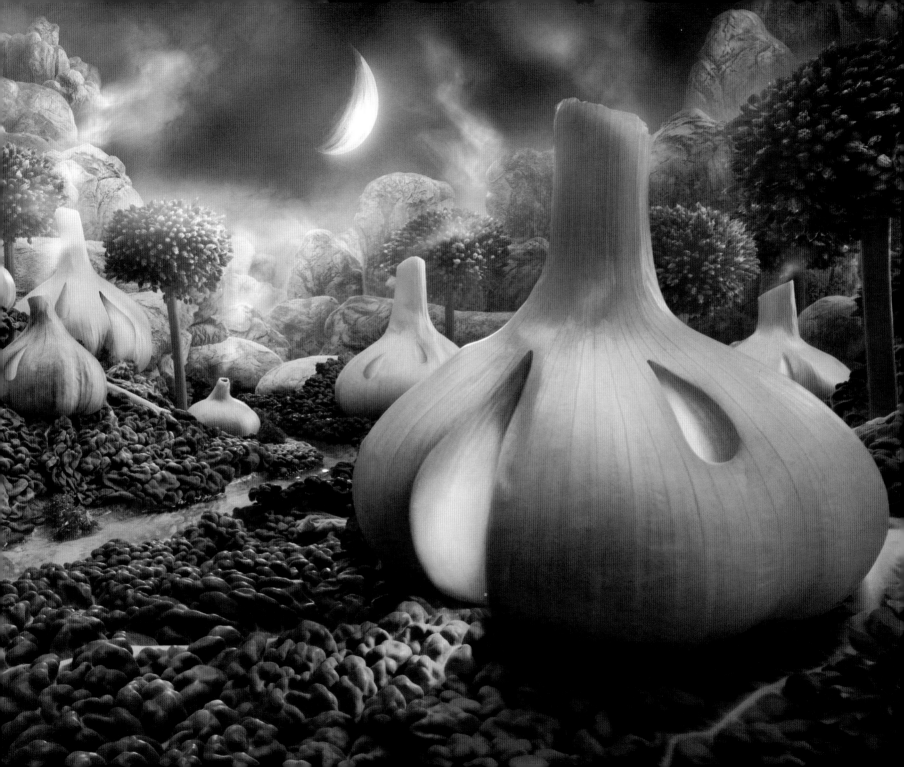

GARLICSHIRE

INGREDIENTS

Houses – *elephant garlic, purple Moldavian garlic bulbs*
Ground cover – *Savoy cabbage leaves*
Trees – *garlic alliums*
Foreground bush – *Greek basil*
Stream – *garlic oil*
Stones in stream – *garlic cloves*
Rocks and mountains – *garlic bread, ciabatta*
Moon – *garlic clove*

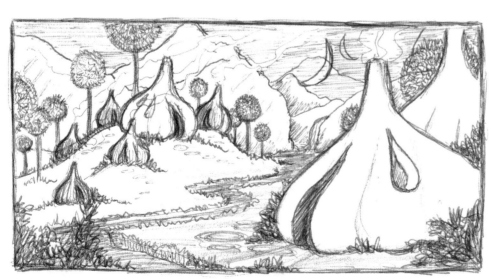

For the past few years, I have exhibited my work at the Royal Horticultural Society Flower Show at Hampton Court, which was home to Henry VIII, just outside London. There my work is shown in the Growing Tastes tent next to specialist growers in the world of fruit and vegetables. It is a wonderful week in July when we celebrate the British summertime with the usual array of umbrellas and Wellington boots. For me it is a great chance to meet people and to see their reactions to work both new and old. Seeing people's expressions change and their faces light up when they realize that the scenes are all made of food is something I never tire of watching.

The first year I was there I had the great pleasure of meeting Colin Boswell, who runs The Garlic Farm on the Isle of Wight off the south coast of England. Colin is fanatical about garlic and travels the world in search of its many varieties.

Colin's stand at the show was opposite mine and so when the show had ended, I showed Colin a sketch I had been quietly working on, which was inspired by seeing huge garlic bulbs on his stalls called elephant garlic, which were about the size of grapefruit.

The drawing showed a Tolkien-esque scene in which the garlic bulbs were portrayed as dwellings clustered together in a small hamlet surrounded by garlic alliums, which made for wonderful trees, and a stream of garlic oil that ran through a landscape of garlic bread hills and mountains, where Savoy cabbage provided a bed of soft vegetation on the valley floor. The whole scene was to be bathed in moonlight from a garlic clove moon, which would shine through the ghostly clouds of smoke that rose out of the chimneys of the sweet garlic homes.

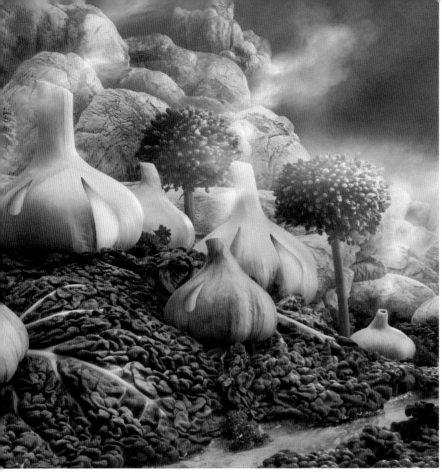

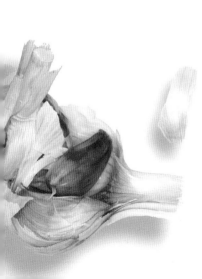

Left: The garlic-bulb homes bathed in moonlight.
Below: The garlic-clove crescent moon.
Opposite: Garlic bulb houses that grow with the family.

In this dreamlike fairy-tale world, I loved the idea of an organic house that grew with you as you became older, so small single dwellings for bachelors would grow in size through the years to accommodate the addition of wives and children. Perhaps moving to another part of this edible world would involve attaching the garlic house to a hot-air balloon, which would lift the bulb out of the ground and carry it off in the wind to find some other place to colonize. It certainly puts a fresh spin on "putting down roots."

Having finished explaining all this to Colin (who by now was clearly thinking that I was on some kind of medication or hallucinogenic mushrooms), I was delighted to see him piling garlic bulbs and alliums from his stand into my arms, and with a wry smile wishing me the best of luck.

Back in the studio, the scene started to take shape as I plunged pins into polystyrene to bed in the Savoy cabbage. From large elephant to small purple Moldavian, the garlic bulbs fell into place to give the perfect scale and perspective I was looking for. Lavender gels on the lights brought the magical mystic of twilight, and with miniature lights, cigar smoke, and a lot of very sympathetic retouching, Garlicshire

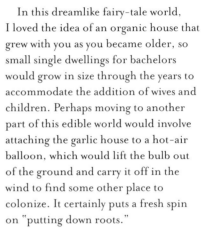

was put on the map of "Middle Earth."

Having tried to make most of my scenes look as realistic as possible, so as to fool the viewer that at first glance the scene is real, it was really enjoyable to wander off into a fantasy world that still has a sense of realism about it. It was like the early science fiction images I started out with, that created a fantasy world but with all the rules of lighting, scale, and perspective that are essential in making the images work. I realized after making this image that I need not be restricted in trying to create scenes that looked like the natural world, but that I could explore other worlds of fantasy and fiction, as long as I stuck to the rules of visual arrangement that I had prescribed for myself within the work. The following year I returned to the show with a large print of the Garlicshire scene as proposed, which Colin now proudly hangs in his restaurant on the farm, though I suspect he still thinks I am "one sandwich short of a picnic"!

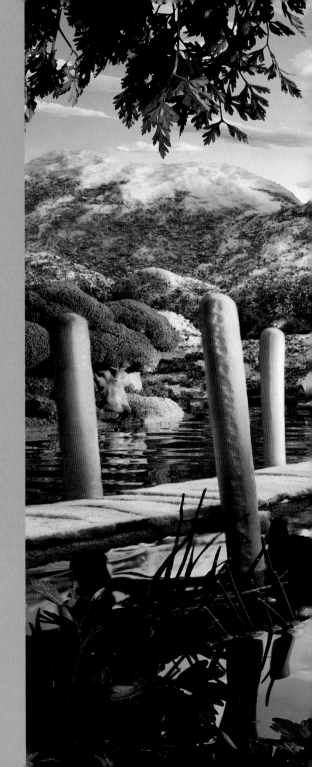

Cheesescape

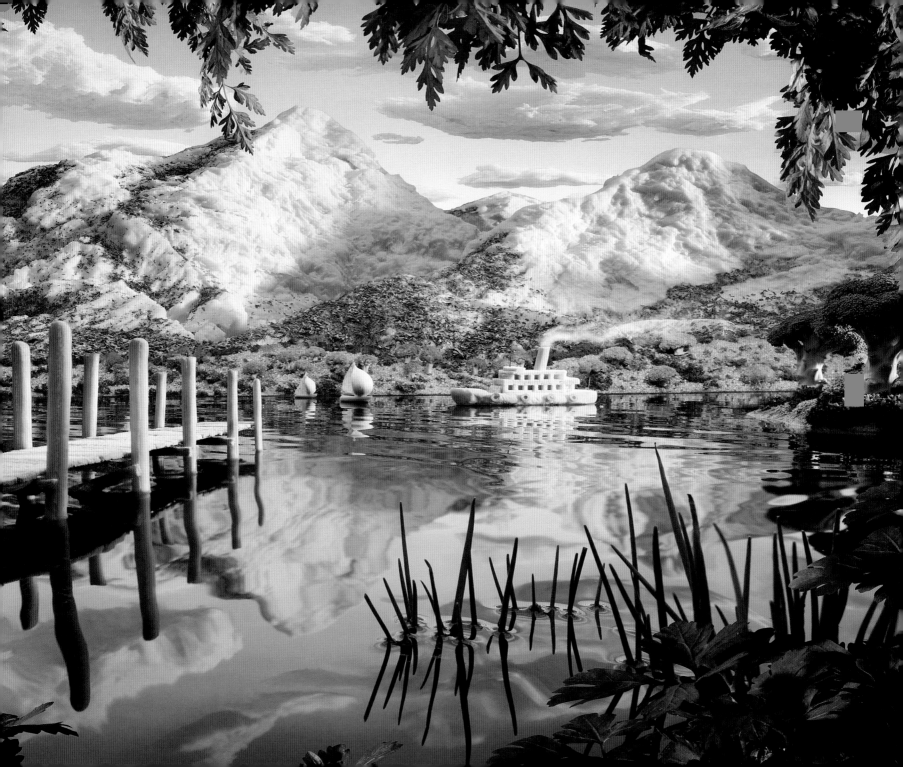

CHEESESCAPE

The Lake District Cheese Company is owned by a group of dairy farmers in the north of England, and their advertising agency approached me to re-create a typical scene of this most beautiful part of the country. Having visited the area on a few occasions for various photographic shoots, I have come to realize that the one thing you can always be sure of is the rain, without which of course, there would be no lakes nor vivid greenery. However, if you are lucky enough to be there when the sun is out, it is a stunning place of great beauty reflected in the mirrorlike expanses of cold mountain water.

The brief was to make the scene out of their cheese, most of which was yellow, a bit of a tall order considering the fact that most of the Lake District is lush and green. I decided to use the shapes and forms of the landscape so as to trigger the recognition of this location in the minds of the viewers from their memories of pictures and postcards, as well as from the films and TV series shot there over the years.

Many of the lakes have long jetties that reach out into the deeper water, and on one lake, Windermere, a white steamboat called *The Teal*, sails up and down the lake taking tourists on pleasure cruises for the day, and this I felt was another iconic image of a typical Lake District scene. So together with jetty, lake reflection, and mountain shapes, we had a good chance of making this recognizable enough even though we were making use of a lot of yellow cheese.

The first big hurdle in creating this image was one of scale. I needed to make mountains out of cheese, but their shape and texture were very much dictated by the size of the cheese blocks that came from the company. As the back of our set was about ten feet across, we would have needed to work with blocks of cheese that were three to four feet high to get the scale right. This was

a problem not only in terms of weight, but also in the texture of the cheese, revealed when you split the blocks apart, which would be too small to see clearly in the eventual print ad and therefore unrecognizable as cheese.

This all meant that we had to shoot the cheese mountains separately at a smaller scale from the lake scene, but we still needed to see its reflection in the water. Having built a large triangular tank of water in the studio to fit onto my tabletop, I had a large ten-foot print made of the cheese mountains together with a sky of soft, white bread clouds, and this was hung at the back of the set, and reflected beautifully onto the surface of the water. At the back of the tank, we dressed smaller hills and broccoli trees so that the join wouldn't show, and as I had sprinkled chopped herbs onto the lower slopes of the cheese mountains, the blending of the two elements seemed to work well despite their difference in scale.

After building the shallow water tank, Paul the model maker set about making a wonderful wooden jetty from wheat crackers and breadsticks, and then *The Teal* from a small baguette to act as a hull, some sliced bread for the decks, and a celery funnel then completed the steamer. Smaller sailing boats were made from more celery with

INGREDIENTS

Clouds – fluffy white bread
Mountains – cheddar cheese with chopped parsley
Far lake shore – chopped parsley, kale, broccoli trees
Steamboat – small baguette hull, sliced white bread decks, celery funnel
Small sailboats – tortilla chips, garlic cloves, celery
Jetty – breadsticks, crackers
Foreground trees, plants, and rushes
flat-leaf parsley, oregano, chives
Lake – water

tortilla chips and large garlic cloves for the sails.

At the end of a long day, everything was in place and ready to shoot, but as the reflection was a little too perfect, we needed to make tiny ripples in the surface of the water to slightly break up the image in the lake. With small wooden paddles and a few vibrating adult toys, Paul, myself, and the art director placed ourselves strategically out of shot and on the count of three dipped our various instruments into the water to create the ripples. After a few seconds, the giggling and sniggering turned into laughter and then oxygen starvation coupled with incontinence. Twenty minutes later, with bleary eyes, aching jaw, and red face, I eventually managed to take the shot.

Thankfully it worked really well and brought more of a sense of realism to the scene that the still reflection lacked. I finally added some fresh herbs to frame the shot and give the image another layer of depth and detail with which to enhance the illusion. But I have to say that I cannot look at the image without the memory of that last twenty minutes and the absurdity of it flooding back. The pictures taken during the making of this part of the scene will not be shown, of course, as children should never see three very immature adults reduced to tears in this way.

Below, top: A close-up of *The Teal* made from bread.

Below, bottom: My assistant Andrew filling the tank with water.

Left, top: A studio shot of the tank in the foreground and the large print at the back of the set.

Left, bottom: Jetty detail with the garlic-clove sails.

Opposite: Paul assembling the split cheese blocks for the mountains.

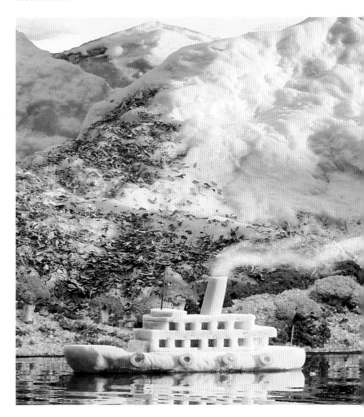

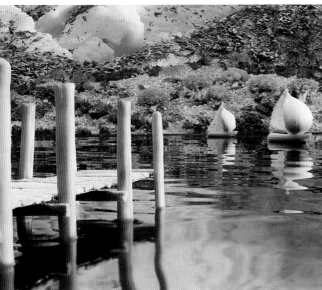

Gondola

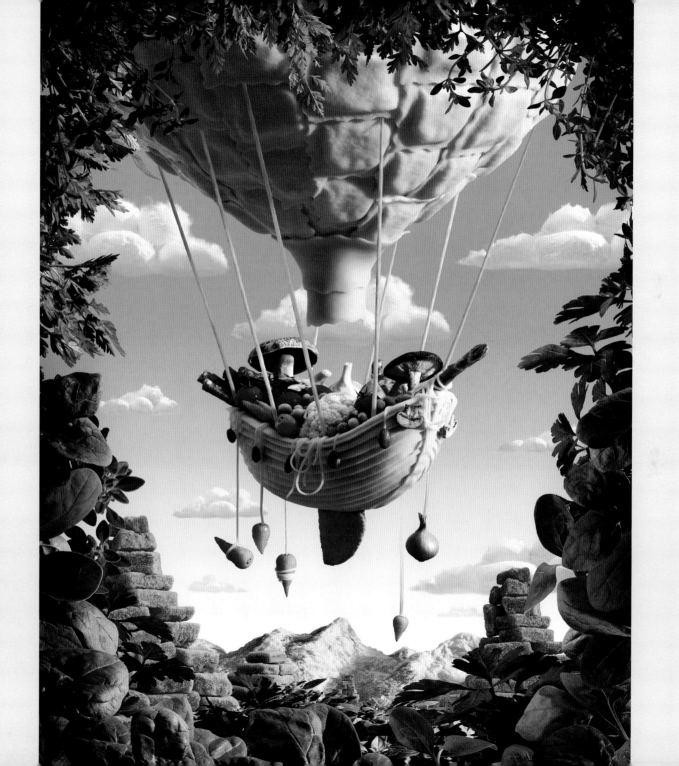

GONDOLA

Frozen food is not high on my home shopping list, especially when it comes to all things Italian, such as pasta and risotto, but just outside of Rome, Italian food experts have pioneered groundbreaking methods of freezing that have enabled them to freeze these types of food at the point in which their freshly cooked state is perfectly preserved.

The company, which is owned by Unilever, was having a grand opening at a new factory to show off this new technology and I was invited to create a piece that would be shown at the launch, and to talk about my work in front of the heads of one of the biggest food giants in the world. This also meant a nice trip to Rome, so all in all they made me an offer I couldn't refuse!

The hard part was to come up with an idea and an image that would capture the aspect of freshness that the company prided itself on, together with the fact that this was not just about Italian food, but dishes and ingredients from all over the world; so in order to get the balance right, it had to be some kind of Italian vehicle that was collecting food from around the world.

My initial thoughts were of making a ship that would be laden with ingredients, but this tied me into a seascape or a riverboat and felt a little old-fashioned for a company and a process at the cutting edge of the industry. I needed more of a sense of inventiveness and adventure, an image that would sum up their pioneering spirit as well as their passion for food.

All this was rolling over in my mind while sitting with the head of the plant in the staff restaurant. My ad agent and

INGREDIENTS

Balloon – *ravioli parcels*
Ropes – *spaghetti*
Gondola hull – *tagliatelle with crispy pancake fin, asparagus mast, mushroom anchors, bean buffers*
Cargo – *mushrooms, peas, carrots, asparagus, garlic, cauliflower, tomatoes, salami, shallots*
Clouds – *mozzarella balls*
Mountains – *cheese*
Temples – *frozen tomato and mushroom sauces broken into blocks*
Foliage – *baby spinach, basil, thyme, oregano, parsley*

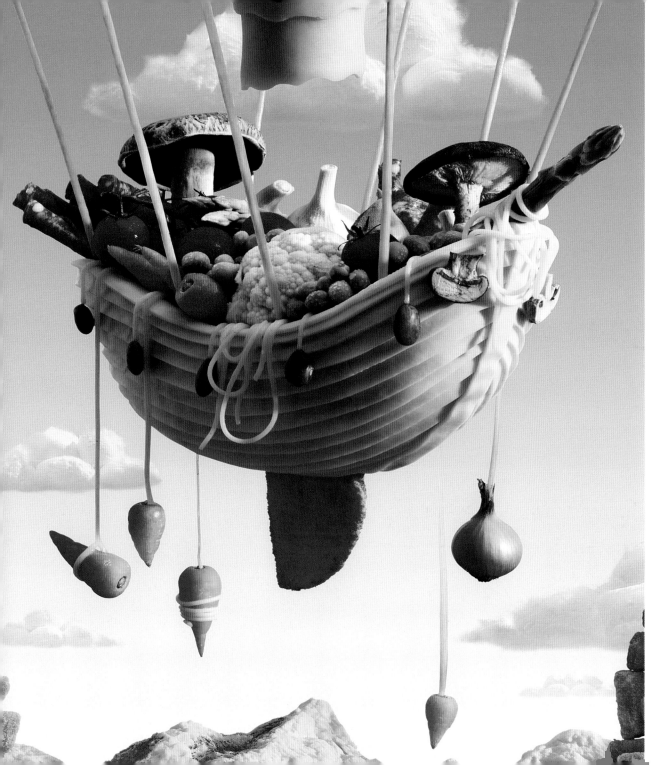

Left: A close-up of the gondola hull.

Below: Fixing the balloon of pasta onto the wires.

Opposite, right: This was the final sketch that the client approved, which combines the merchant ship and the hot air balloon.

Opposite, left: Carefully filling the gondola with its cargo.

I were being fed different dishes, from fresh pumpkin soup to paella. Each one had been cooked from frozen, but the taste and texture was that of something that had been freshly prepared. We were both quite bowled over by the quality and the taste, but it wasn't until the pasta came along that the Italians really got excited, as for them it is their pride and joy. I took some ravioli from the bowl and ate a mouthful, expecting it to be sloppy and slimy, but to my amazement it was, as they say, "al dente," the texture and firmness just incredible, and I knew I had to make pasta, and in particular this ravioli, a major part of the shot.

As I tucked into another delicious mouthful it dawned on me how these pillows of pasta could be sewn together to be the gas pockets of a hot-air balloon, and remembering an old illustration from the great Patrick Woodroffe of a Jules Verne–style ship under a balloon, I knew that by putting the two elements of ship and balloon together I would be able to create the visual metaphor for innovation and versatility, while retaining the whimsical quirkiness of it all being made from food.

Inca temples made from blocks of frozen sauce.

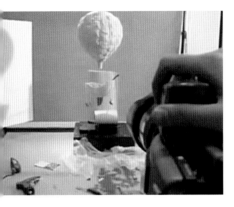

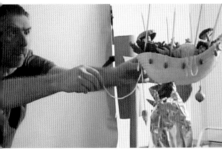

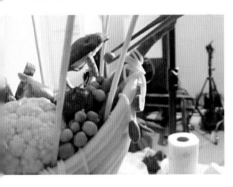

Below: Carl's pained expression of concentration.

Left, top: Shooting the balloon element separately allowed more flexibility with the composition.

Left, center: Paul stretching across the set to hang the spaghetti ropes.

Left, bottom: Hull detail with its cargo of food.

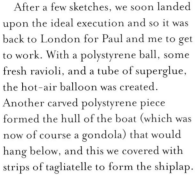

After a few sketches, we soon landed upon the ideal execution and so it was back to London for Paul and me to get to work. With a polystyrene ball, some fresh ravioli, and a tube of superglue, the hot-air balloon was created. Another carved polystyrene piece formed the hull of the boat (which was now of course a gondola) that would hang below, and this we covered with strips of tagliatelle to form the shiplap.

Suspended on metal rods in order to take the weight, the gondola was filled with the different ingredients it had collected on its journey so far. The balloon was then suspended above it to line up with the spaghetti rigging and then dropped onto our sky background of mozzarella clouds.

One of the most important ingredients that the company was very proud of were their fresh sauces, which were frozen into blocks. These would be added to the rest of the ingredients in the bags of frozen food so that upon heating they would melt onto the pasta, and this would be the first time the two elements had combined, so ensuring greater freshness at the cooking stage. At first I was going to just stack them into the gondola, but they were quite large and didn't really resemble anything; in fact they looked more like

blocks of stone, which then gave me the idea to use them as that in order to create some temples and ruins over which the balloon would be flying. Finally I assembled a surrounding framework of fresh herbs to complete the scene.

A few weeks later, I flew out to Rome to give my talk and unveil the work together with a short film showing Paul and me hard at work on the piece. Afterward, we were treated to a wonderful dinner, though I am not certain that any of it came from the factory!

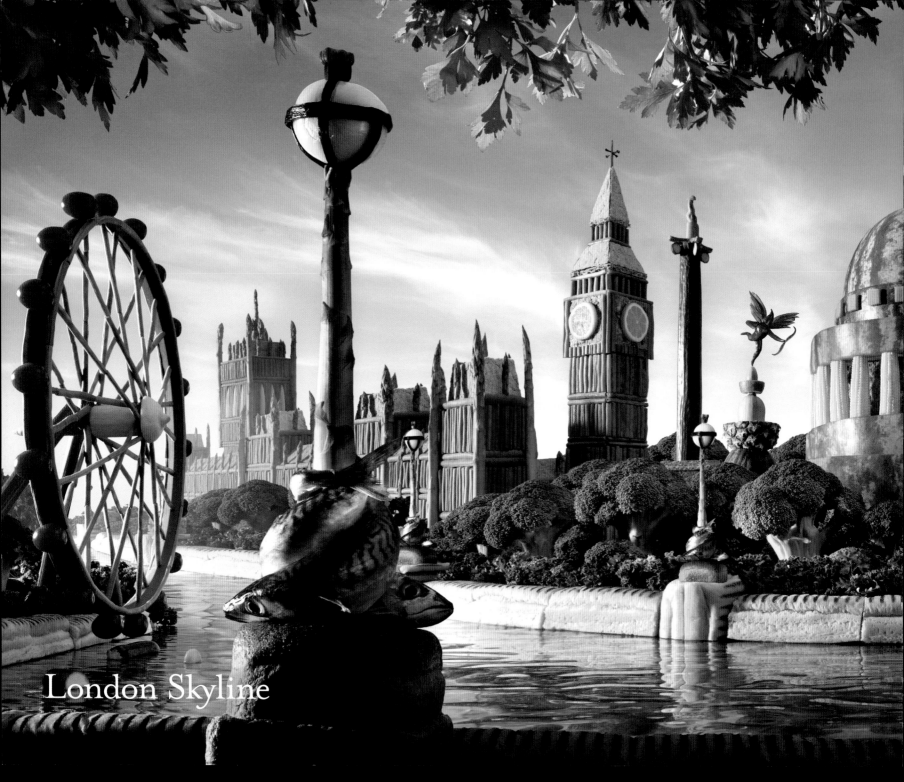

London Skyline

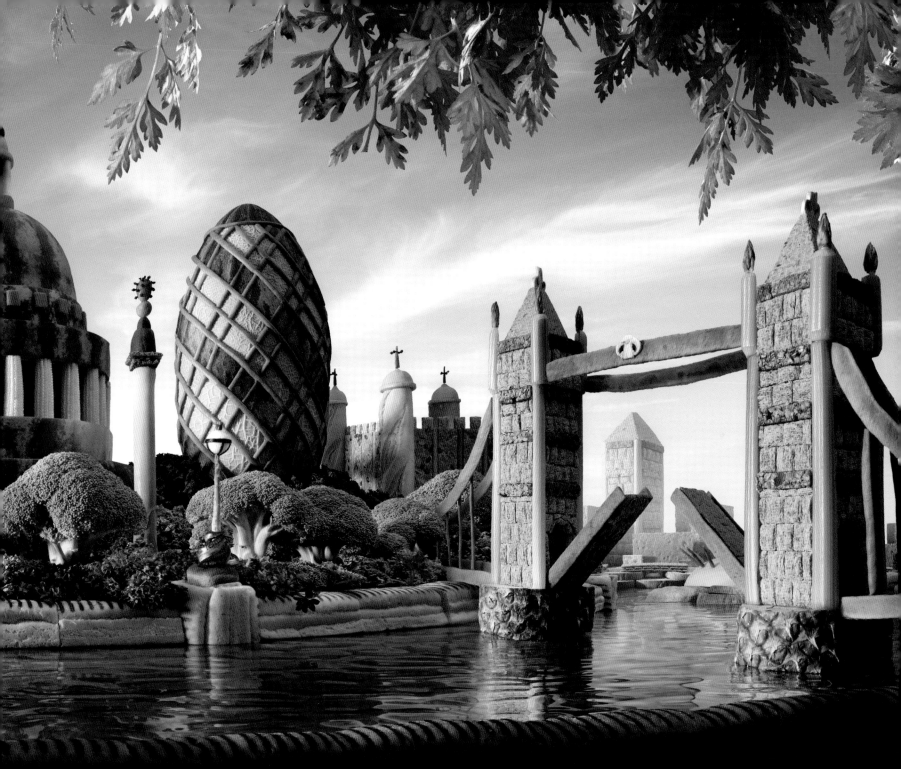

LONDON SKYLINE

I had been approached a few times about making a London skyline out of food, but no one would commit to commissioning it. Finally, the Good Food Channel in the United Kingdom decided to go for it and so I began to think about which iconic London landmarks we would use and, more important, what we should make them out of.

The brief was to use healthy ingredients, such as fruit and vegetables, so we had to decide what the scale of each building would be, as this would determine the size of the overall set. The first choice was easy: St. Paul's Cathedral, one of the oldest and most well-known shapes on the skyline of London. Its large dome needed to be made from the largest round fruit I could think of, a watermelon with its yellow stripes echoing the lines on the dome. This would dictate the size of the model and in turn the rest of the scene, so I decided to plonk it in the center of the shot as the largest and most dominant feature.

As London's most famous buildings are sprawled along the river Thames, the view I was going to create needed a great deal of artistic license, as in reality, all these buildings are much farther apart from one another, with other less interesting buildings in between. But as I always like to entertain some kind of realism or believability, it was important to me that the landmarks remained in the same order of how they are located geographically, and by using the technique of a very wide, almost fisheye lens, I wanted to create the illusion that they could all be viewed in one scene from one point of view.

INGREDIENTS

Riverbank walls – panini

Trees and bushes – broccoli, curly kale, flat-leaf parsley

Lamppost – mackerel, asparagus, onion lamp with vanilla pods and baby courgette top

London Eye – green beans, courgette, leek, lemon, rhubarb supports with baby plum tomato pods

Houses of Parliament and Clock Tower (Big Ben) – green beans, runner beans, asparagus, crisp bread, sliced lemon

Nelson's column – cucumber, courgette, carrot, monkey nut, brown bread base

Eros – green chilies and peppers for the statue, kumquat, lime, butternut squash, pineapple, and melon for the base

St. Paul's Cathedral – green bean cross, yellow courgette, baby leeks, watermelon, carrots, baby sweet corn

The Fire of London Monument – leek column, crisp bread, cucumber, kumquats, cloves

St. Mary's Axe (a.k.a. "The Gherkin") – honeydew and green melon, green beans

Tower of London – French bread, lemons, green beans, spelt crackers

Tower Bridge – runner beans, celery, asparagus, shredded wheat cereals, pineapple bases, crisp bread roofs, mushroom crest

The Dome – melon, green beans

Canary Wharf – crisp bread, cereals

Top: An aerial view showing how the bases were hid behind the foliage.

Bottom: London's famous Eros statue in Piccadilly Circus, made from green chilies.

The key to making the image work was to hold them all together with the use of a common continuous thread, that being the river itself and the Thames embankment. This would act as a foundation platform to mount all the buildings and landmarks on so that they didn't appear disjointed.

As we shot this in November, we had to cast our minds back to the summer, and how the road running along the embankment has many trees and is very green in places, so the usual suspects of broccoli trees, parsley, and kale quickly filled the space behind the panini bread walls, which gave us an easy way to hide the bases of each model in order to bed them into the scene.

Model makers Paul and Neil then began work on Big Ben and the Houses of Parliament, which were made predominantly out of green beans and asparagus to keep a consistency of color

and to provide the vertical lines that make up the architectural structure of the buildings. It took them two days to build all the sections, and due to the fact that green beans and asparagus dry out and wrinkle very quickly under the lights, I had to shoot each part separately in order to keep it looking fresh for the final image.

This is in fact the first image that has had nearly every element shot separately, as to shoot it in one go would have required a team of about twenty model makers and a studio nearly four times the size to accommodate them. Therefore, I had to make sure that each individual building is placed in exactly the right place in the scene, so that they match perfectly with the scale, proportion, and wide-angle distortion that the lens gives to them, as well as the lighting and the shadows they would cast upon each other. It's this attention to detail and consistency of shooting with a locked-down camera that creates the illusion that it is all shot as one—that and of course my wonderful retoucher Steve, whose expert eye ensures that nothing looks like a cut-and-paste job!

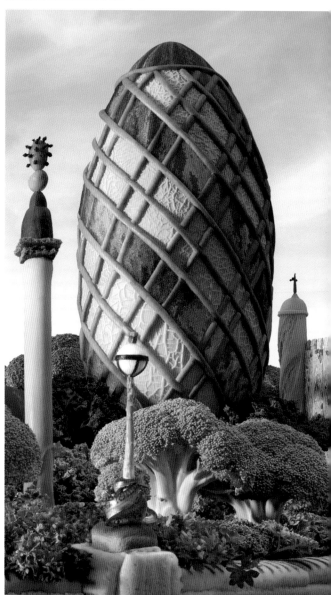

The London Eye, or Millennium Wheel, as it was first known, started life as a children's bicycle wheel, which was taken apart, sprayed green, and threaded with green beans, then edged in courgette (zucchini) skins and decorated with baby plum tomatoes for the pods. The structure has become one of the most popular and elegant landmarks of the city, and with its rhubarb supports it provides a vibrant splash of color to the scene.

St. Mary's Axe, or "The Gherkin," as it is more commonly known, doesn't look at all like a gherkin, and I was very reluctant to use one or even something in the family such as a marrow squash. Instead I went for melons, which kept the scale of the building in keeping with St. Paul's and whose bulletlike shape was much closer to the shape of the building. We spliced together two different types of melon to give us the stripes reminiscent of the different colored glass, and we laced it with green beans to re-create the lattice-work of steel bands that spiral around its outer skin. This took Neil the best part of a day to build despite being horse-whipped and verbally abused by yours truly.

The Great Fire of London Monument and Nelson's Column came together quickly due to their simplicity, as did the Tower of London and Canary Wharf. Not many people notice the Millennium Dome creeping under Tower Bridge, but these are nice things to discover along the way. Paul excelled with the statue of Eros, which was made from green chilies, but the best part for me are the fish lampposts that line the promenades of the embankment, and in this version, I have included one in the foreground to give the image another layer of depth.

The whole scene was shot with the look and feel of early-morning sunlight, which makes these iconic landmarks look their best, and with a gentle mist over the distant buildings. I think we captured the spirit of the city and achieved a sense of standing on the embankment and looking out across the river Thames. Not bad for a pile of fruit and veggies on a tabletop!

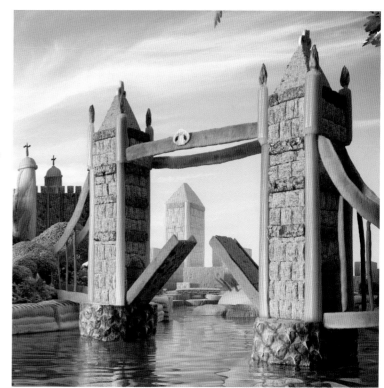

Stilton Cottage

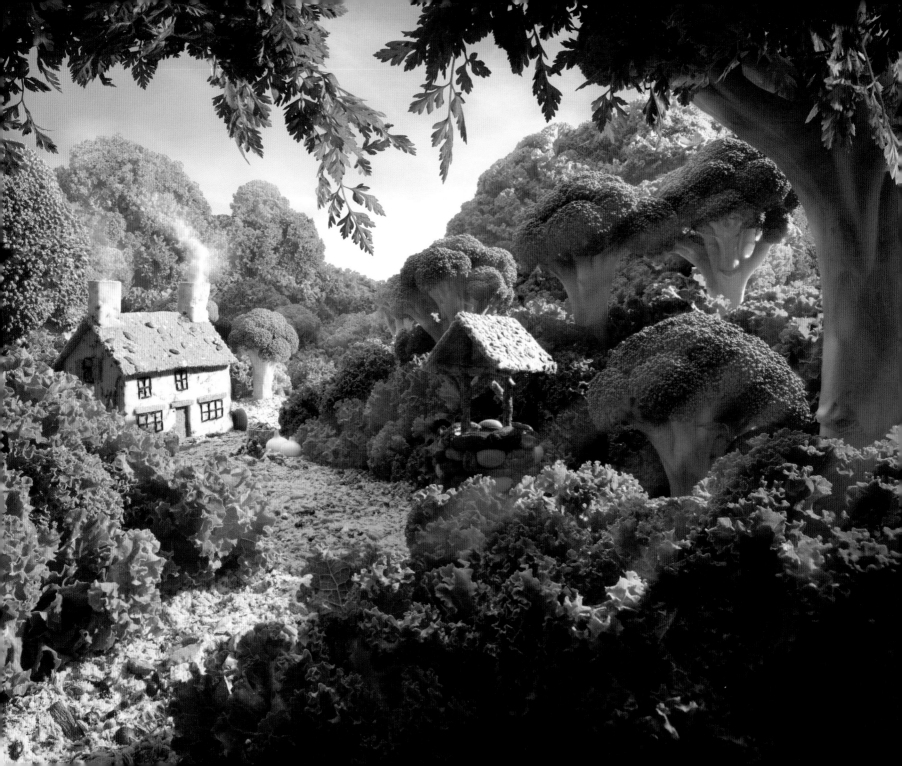

STILTON COTTAGE

INGREDIENTS

Trees and bushes – broccoli, curly kale

Cottage – stilton walls, spelt cracker roof, black rice window frames

Wishing well – nut base of almonds, Brazil, and hazelnuts, spelt cracker roof

Pathway – ground almonds, seeds, rice, couscous

Sacks – white onions

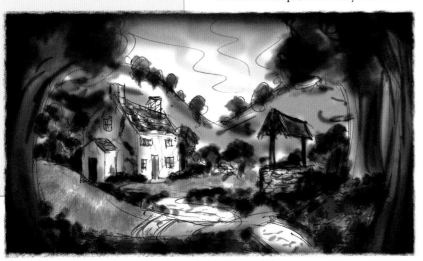

After the rush of newspaper and magazine articles as well as Internet blogs and viral e-mails featuring my images, I began to get requests from TV shows wanting me to create food landscapes live on television, but unfortunately I had to decline these requests, as the process of my work doesn't allow for a finished, all-in-one-scene experience. The food landscapes have to be seen from one viewpoint and lit properly to create the atmosphere and mood that gives them the realism needed to enhance the "double take."

Realizing this, the production companies began coming to the studio to watch and film me and the team at work. One such occasion was for a TV show called *Gastronuts*, a kids' show hosted by Stefan Gates, who takes children on journeys around the country to learn about food and diet in order to encourage awareness within young people about healthy eating.

The idea was for Stefan and the kids to come to my studio and help me build a food landscape, which they would be able to eat a bit of when it was finished.

Although I didn't consider this to be a project that would be added to the collection (as the idea was very simple and we only had a few hours to do it), I was very pleased by how it turned out.

Upon arrival, the children seemed fascinated by the previous work, which I showed them in the entrance hall of the studio while the cameras caught their expressions of amazement and wonder at the way in which the textures, shapes, and forms of food could mimic the reality of actual places and landscapes.

Once they were taken into the studio they quickly became immersed in this world of food and began planting broccoli trees and curly kale with such skill and dexterity that I began to question whether my highly paid team was really so necessary after all!

As we had such a short time to film the set being built, I kept to the tried and trusted things I had made before, so a Stilton cottage that was made for an earlier scene was quickly remade, and Paul helped by gluing together some nuts to make the base of a wishing well. This was to be filled with a cheesy dip that the children would later eat.

Before I knew it, the scene was ready to shoot. The children looked through the lens and watched the images appear on the computer screen as I fired the shutter. There were lots of "ooohhs" "aahhs" and "wows," and I began to wonder why my own crew never reacted like this or made such excitable noises. Too cool for school, perhaps?

It was a great afternoon, and after they left, the studio was strangely and sadly quiet as my team stared into space like shell-shocked soldiers. Having had four children of my own, it just seemed like old times to me, so I headed off to my computer and added a few beams of sunlight and some smoke from the chimney to finish off the picture. Not bad for a couple of hours work; I should get them back again!

Below, left: A close-up of the nuts (base) and crackers (roof) wishing well.

Below, right: Stilton farmhouse detail.

Opposite: A very simple sketch of the Stilton Cottage, which I knew could be assembled quickly and easily.

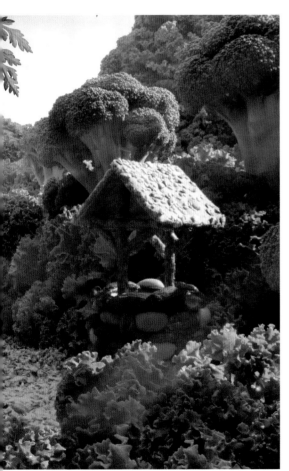

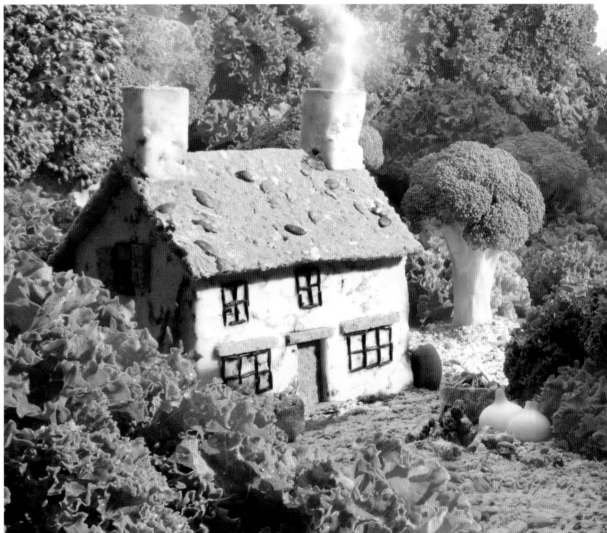

Chinese Junk

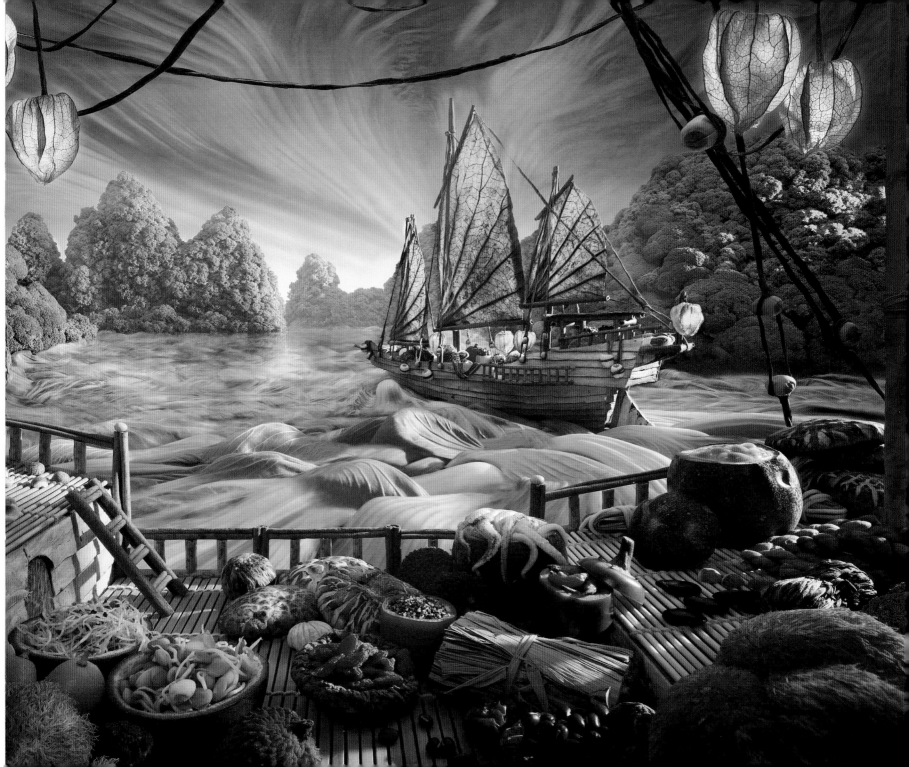

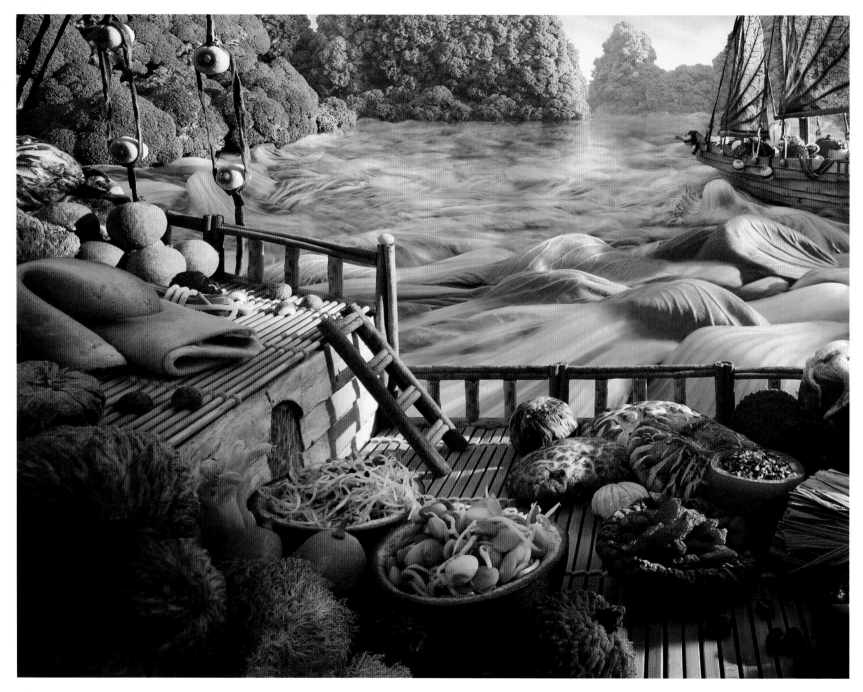

Having submitted my sketch to Swire and receiving their approval, Paul and I began to make visits to Chinatown to look at all the weird and wonderful ingredients that Chinese cuisine makes use of. The first thing I discovered were large dried lotus leaves, whose structure was perfect for the sails. The second great discovery was a dried root similar to licorice, which would be ideal for the shiplap strips of wood that make up the hull of the junk. Armed with these two ingredients, we were confident that we had the main ingredients in place to build it, so Paul sent off for a model on eBay of a wooden junk, which could be made in kit form. This kit came with a wonderful scale plan of the model, so Paul (who loves a good bit of reference material) had the perfect blueprint with which to construct his "Food Junk."

A couple of weeks later, having built both the junk and the foreground deck of another, he arrived at my studio with both models complete with balustrades and cinnamon stick masts. Having placed them into the set, we dressed around the hull with bok choy, a Chinese leaf whose flowing lines made wonderful waves of the sea and looked almost illustrated, like some piece of stylized Chinese painting. The larger kai choy leaves were shot separately for the sky, which took on the appearance of spooky, swirling, stormy clouds. As the sea often reflects the sky, we used the same ingredient for both in order to establish a visual relationship between them. With broccoli and kale dressing the polystyrene hills, the scene was ready to have the smaller, more detailed ingredients added to the decks.

Having found strands of dried seaweed and lotus nuts for making rigging and pulleys to frame the shot, I wanted something that was going to make a Chinese lantern to add other light sources and enhance the color palette of oriental gold. The beautiful physalis was a clear and obvious choice for this. In order to make them work better for us as lanterns, we replaced the small orange fruit inside with small glass balls through which we shone small flashlights. I particularly liked the way the veins of the lantern resembled the color and patterns of the lotus leaf sails. I then spent ages with the baby squid in the passion fruit barrel before it looked right. The final addition of a fortune cookie as a folded rug added a touch of humor to this sumptuous seascape of golden light and gastronomic treasures.

Celery Rain Forest

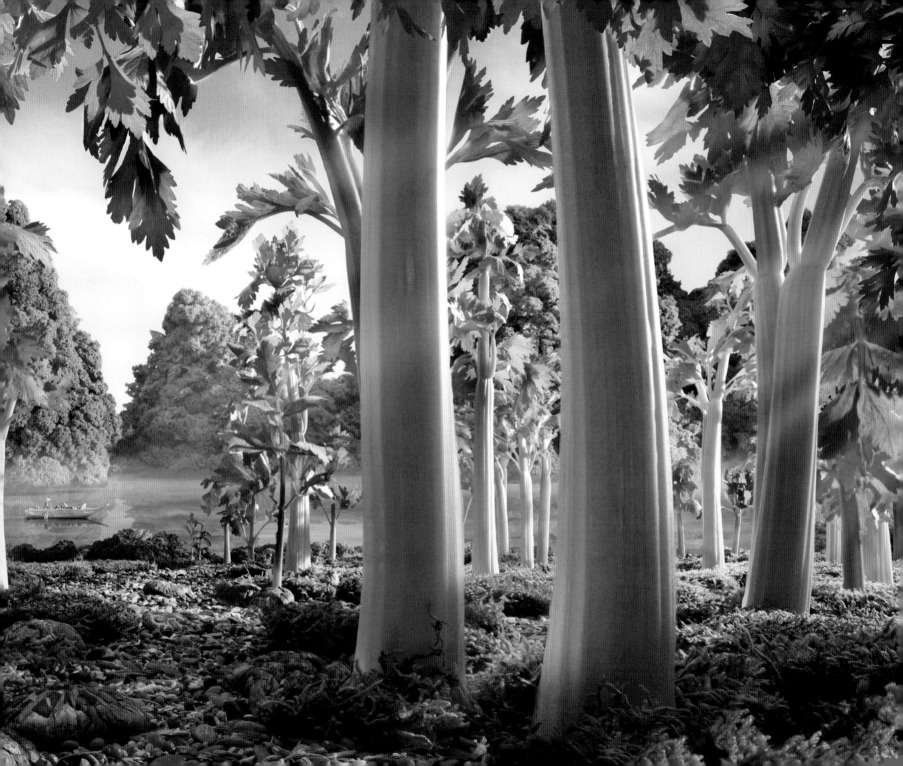

CELERY RAIN FOREST

INGREDIENTS

Distant hills – curly kale
Trees – celery, flat-leaf parsley
Foreground rocks – Chinese dried mushrooms
Pathway – sunflower seeds, pumpkin seeds, lentils
Canoe – okra with dried chili oarsman with a small mushroom hat and a cardamom pod oar

Having used broccoli so many times as trees I thought it might be a good idea to look at other ingredients, so that the work didn't start looking too repetitive. I needed something with a strong trunk and leafy tree canopy, so the next most obvious choice was celery.

Having just finished the Chinese Junk image, which was very complex and used many ingredients, I now wanted to make a simple image using very few ingredients, so a forest of celery trees in a beautiful early-morning light seemed like a good idea that would be easy to build.

I generally work on a large triangular tabletop, the edges of which fall just outside the frame of my wide-angle lens. The back of this table is about twelve feet across and the front about two feet. Resting on the tabletop is a four-inch-thick sheet of polystyrene that is cut to the same size of the table. This means that I can plant a whole host of things such as clips, clamps, pins, and cocktail and satay sticks (skewers) into its surface in order to hold things in place and stop them from falling over.

With the polystyrene painted green to save retouching any gaps in the foliage, I began to plant the celery trees one by one into the landscape, checking the position of each one through the camera as I went along. The placement of each

tree was very important not only for the composition, but so that the light would illuminate each individual trunk and the shadows from their leaves would dapple the light in order to make the scene look as natural as possible.

One of the biggest problems I had with this shot was that the larger, heavier leaves of the celery began to sag very quickly under the warm lights, so clear tape and fishing line were quickly attached to some of the larger branches to prevent this. The other option, of course, would have been to build the scene upside down!

Having dressed the floor of the forest with herbs and moss, I added a stony pathway made from seeds with which to lead the viewer into the landscape. Having taken the shot, I stared at the screen feeling very disappointed and unconvinced by the image; it lacked

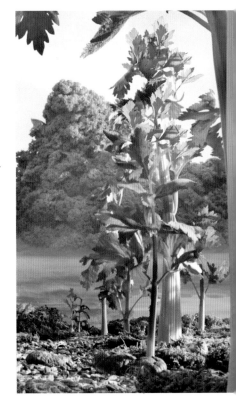

any real depth and it didn't engage me as a viewer, the pathway didn't take me anywhere, and I suppose it was just a bit boring really, as celery for trees just wasn't a strong enough idea to hold my attention, let alone anyone else's.

Rather than abandon the whole thing and head for the pub, I decided to persevere, as I had spent the best part of the day getting it to this point. Looking around the studio, I still had the tall hills from the previous shoot of the Chinese Junk scene, and so I placed them at the back of the shot upon a large sheet of glass to give the impression of a river or lake at the edge of the forest. This not only brought layers of depth and perspective to the scene that it so badly lacked, but instantly gave the landscape more of an east Asian look rather than the North American or northern European look it had beforehand.

From the leftovers of the junk shoot I added some dried shiitake mushrooms to the pathway as ingredients from that region so that the foreground and background would hold together better. But still, something was missing. The image still lacked some kind of focal point, some reason for taking the viewer down this pathway of this now jungle rain forest, a visual prize for wandering into this world. I began to construct

a small canoe from a piece of okra or "old ladies' fingers," as they are sometimes known outside the United States. From a dried chili pepper and a tiny mushroom, I made a small figure with an oriental-style hat. Half a cardamom pod acted as his paddle and I filled the rest of the canoe with a cargo of seeds and pods, which I liked to think he had collected on his way down the river. This small detail not only brought the focal point and visual reward I was looking for, but also suggests some kind of narrative or story of where he has been, or where he is going on his journey through the landscape.

With the final touches of a little mist on the surface of the river and some beams of light through the trees, the Celery Rain Forest was complete. Whereas the Chinese Junk image had more of a painterly feel, this image seemed to resemble more a photograph from *National Geographic* of some tropical Indonesian jungle location. The feeling of realism, together with the tranquillity of the lonely traveler in this sea of calming greenery gives this image a sense of place, which I don't feel I have captured before or since.

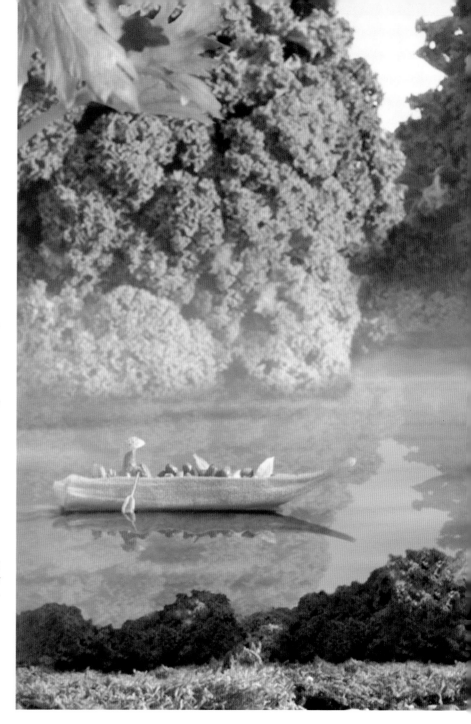

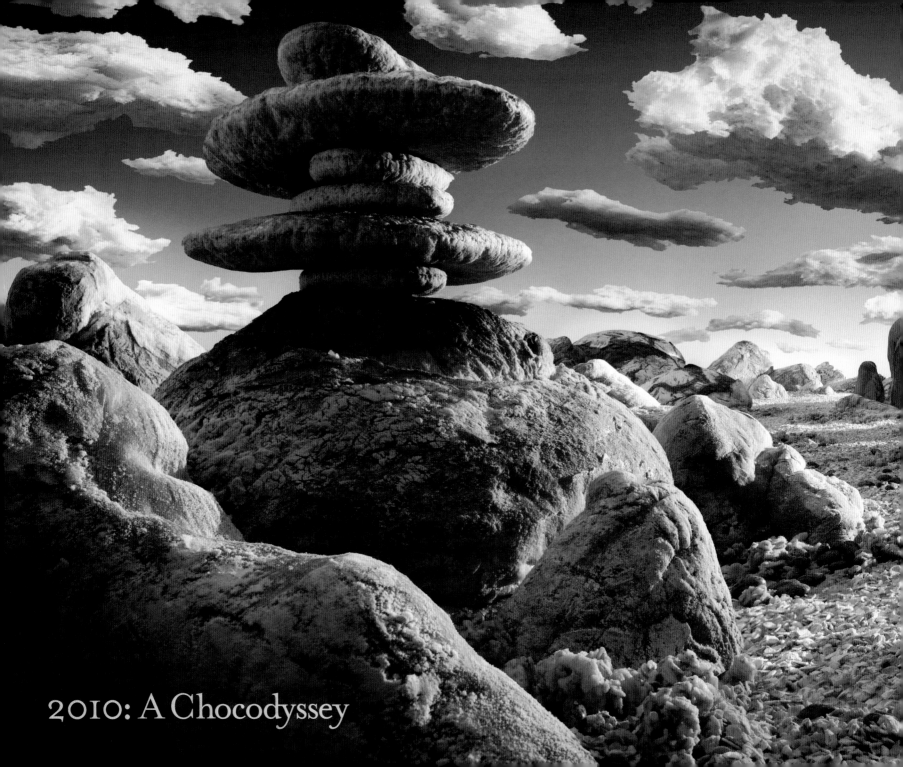

2010: A Chocodyssey

2010: A CHOCODYSSEY

Below, top: One of my quickest sketches for the basic composition.

Below, bottom: The stack of stones made of flat pita breads.

I remember my mum taking me to see Stanley Kubrick's epic science fiction masterpiece at the cinema when I was about seven years old, and I remember being very bored and disappointed that it wasn't the film that eventually came some ten years later courtesy of George Lucas.

Watching it again many years later, however, was a totally different experience, and to this day it still stands tall among the greatest science fiction films of the last fifty years, not only for its cerebral head spin, but for its groundbreaking special effects and model making. Brian Johnson was the special effects director who had previously worked with Gerry and Sylvia Anderson on the *Thunderbirds* series, which was a childhood favorite of mine.

Looking back on it now, it is clear to me that there were two very important things I learned from watching *Thunderbirds*. First, the suspension of belief and the rules of "seeing is believing" could be bent when the viewer was willing to participate and consent to the illusion. For example, we could all see the strings on the puppets, but it didn't matter, as we were happy to be in this created world, and we visually dialed them out so as not to spoil the illusion. Second, despite my eagerness to ignore its imperfections, I learned to recognize the devices that were being employed in order to create these illusions. For example, shooting puppets with diving gear on through a narrow fish tank, with a few bubbles rising quickly and easily, gave the appearance that the action was all happening underwater, and all this without anyone getting wet.

By carefully observing these mini sets and the way they were shot in terms of low camera angles and the scale problems of explosions and water movement, I developed an understanding of the model-made scene, as well as ideas of how it could be improved and developed,

INGREDIENTS

Monolith – *dark chocolate*
Stack of stones – *pita breads*
Rock towers – *French baguettes*
Rocks, hills, and mountains – *ciabatta, crusty white loaves*
Ground cover – *cereal clusters, oats*
Clouds – *fluffy white bread*

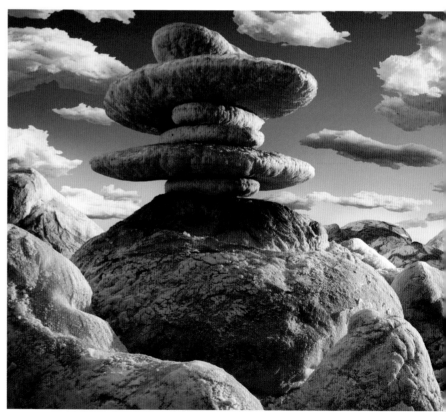

Right, top: Carl playing with food again.

Right, bottom: The chocolate bar monolith.

as all you need in order to do this is a box of toys and a pair of eyes. You can spot this visual awareness easily when observing children at play; the boys who are playing with trucks and have their faces flat to the floor are putting their eyes at ground level in order to look up at the truck so that it appears at a larger scale. These children are watching and making their own movie, and are either copying the camera angles they have seen from films and TV shows, or replicating their own viewpoints of the real world. I think the latter is less likely, as there are not many kids who have seen a fighter plane fly six feet over their heads.

The knowledge and understanding, therefore, of creating my own scenes has undoubtedly come from these early influences, and my subsequent observation of the world since acquiring this way of seeing has enabled me to do what I do now. So as an homage to Mr. Kubrick and the Andersons for helping me get here, I wanted to make a scene in their honor, and so I chose one of the opening scenes in *2001: A Space Odyssey*, where the monolith appears in the rocky desert.

This was one of the few food land-scapes I made by myself, as no model making was required. The Italian deli next to my studio provided me with twenty large ciabatta loaves and I raided the local supermarket for baguettes and several boxes of oats and breakfast cereal. The whole scene took the best part of a day to build and shoot, with the exception of the soft bread clouds, which had been shot for an earlier scene but hadn't featured very prominently.

I was particularly pleased with the stack of pita breads, which looked like the flat boulders that either occur naturally or were placed by ancient tribes who wanted to make their mark on the landscape so that future generations would be aware of their presence. This is an ironic relationship with the monolith, which is supposed to represent or symbolize the mark left by a supernatural or extraterrestrial entity that interfered with the evolution of mankind in order to accelerate and progress its development.

As I'm not really very comfortable with this theology, I thought it much more appropriate and amusing to make the monolith in my desert of bread from a bar of chocolate, a substance that has clearly had a far greater influence on the development of mankind in terms of its sensory pleasure, its use as incentive and reward in childhood education, and of course its necessity in human courtship and the resulting perpetuation of the species.

Crockerville

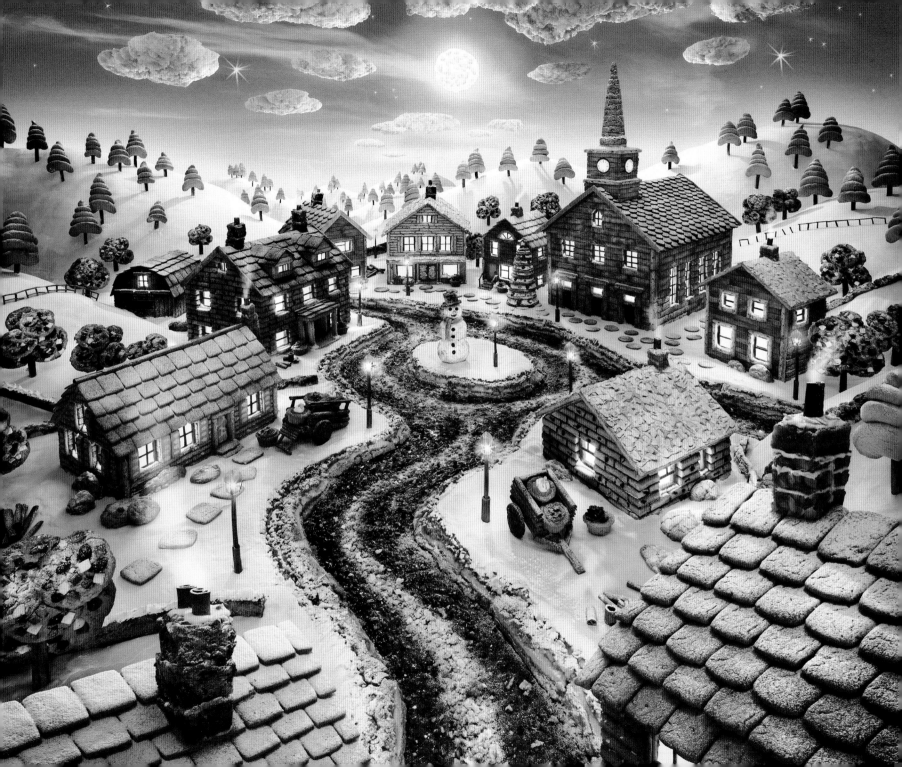

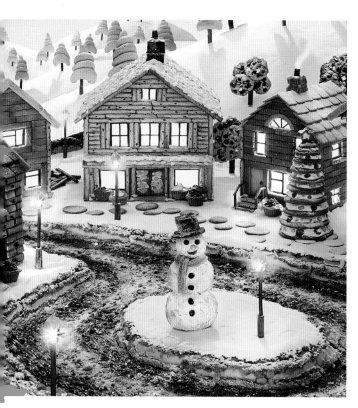

CROCKERVILLE

This is by far the most elaborate and time-consuming scene we have made as of yet. The brief from the agency was to create a winter scene using Betty Crocker cookie mix and recipes, and being a "Brit," I had to research a bit about the Betty Crocker brand and the emotional attachment the product has in the hearts of the American people.

As this was a Christmas ad, I decided to create a scene that had all the magic and atmosphere of a holiday card, but with a traditional feel with which the brand identifies. I also needed to create something that could be constructed using the cookie shapes and textures, so after looking at many different Christmas card designs, images, and illustrations, I decided that a traditional New England village lit by moonlight would be the ideal scene to re-create.

I began in the usual way, visualizing the image I wanted based on the collection of the imagery I had researched, and then putting that which was in my mind's eye onto paper. The resulting sketch made me realize what an undertaking this was going to be, and so it was over to the studio of 3D Models to see Paul Baker the model maker (I love the rhyme), to not only see how it could be done, but to watch him drag his hands over his face as I tested his patience once again.

Our first port of call was with food stylist Lorna Rhodes, who specialized in baking and had been working on the Betty Crocker brand for many years, so she was very familiar with the product. Lorna set to work baking a whole array of cookies and Betty Crocker recipes with Paul overseeing everything that

came out of the oven. This was a lengthy process that left Paul a few pounds heavier, but with all the cookies he needed to construct "Crockerville."

Back in his studio, polycard buildings were constructed as templates to determine the size and scale of the scene, and I arrived to take a snap of these roughly in place to ensure we were on track before they were clad in cookies from Lorna's very tired oven.

A few weeks later, the cookie-clad houses, barn, stores, and church arrived at the studio in all their splendor. The base of polystyrene had been cut with hot wires to form the path for the "rocky road" cookie recipe. This was a fairly obvious choice, not only because of the name, but also because of the fact that it resembled a wet muddy road upon which the moonlight would reflect perfectly. The snaking road also acts as a device with which to draw the viewer's eye into the center of the picture. This is an old painter's trick, and one I use a lot, as it helps to lead the eye on a journey through the landscape.

As the scene was to be covered with snow, I needed to give the appearance that it had been cleared and stacked up at either side of the rocky road, and "apple streusel" was the perfect recipe choice for this effect. Elements such as

INGREDIENTS

Village:

Bricks and walls – chocolate mallow cookie pie, ginger almond biscotti

Roof Tiles – pecan sandies

Body of the manor house – chocolate chip biscotti

Roof of manor and barn – chocolate peanut cookie treat

Body of general store – pistachio cranberry biscotti

Roof of General Store – Scandinavian almond cookie

Roof tiles – Mexican hot chocolate cookies

Clockface – ginger lemon delight

Flower tubs – turtle tassies

Snowman – macaroons

Road – double chocolate rocky road cookie bars

Side of road – apple streusel cheesecake bars

Lamp posts – cinnamon, vanilla pods

Landscape:

Snow – fondant icing

Trees – spumoni chunk cookies with cinnamon trunks dusted with icing sugar

Fir trees – almond crescents with icing sugar

Sky:

Moon – Italian pignoli cookie

Clouds – white coconut macaroons

this had to be laid in fresh on the day, so Lorna spent all weekend baking even more cookie recipes in order to dress the landscape around the buildings. Trees, walls, chimney stacks, bushes, and clouds were all baked fresh, and the studio was filled with the smell of cookie heaven, though my long-lost sense of smell meant I didn't float around the set as well as the rest of the crew.

After six weeks of preparation and three days of building in the studio, the scene was almost complete, but the hour was late, and I decided to call it a day and shoot the following morning so we could all look at it with fresh eyes. But that night I lay awake imagining what damage a very lucky bunch of mice could inflict upon the set, and wondered whether I would enter the studio the following morning to find our

village in ruins with half a dozen extremely bloated rodents lying fast asleep in the middle of the town square. Thankfully, this was just my imagination working overtime, and we all assembled the next day to witness the lighting up of Crockerville as the many bulbs and wires were connected to give life to our twilight town.

After I had taken the final exposure of the scene, we all stood for several minutes in near silence staring at the incredible edible scene that we had all worked so hard and spent so long in helping to create. Having captured the magic, atmosphere, and beauty of this cookie wonderland, it was now my sad and reluctant duty to finally ask the team for it all to be dismantled.

Left: Neil sprinkling fondant icing on the roof tiles.

Above: The sketch for the agency and client.

Top: A typical New England church with clock tower and spire.

Cowboy Valley

COWBOY VALLEY

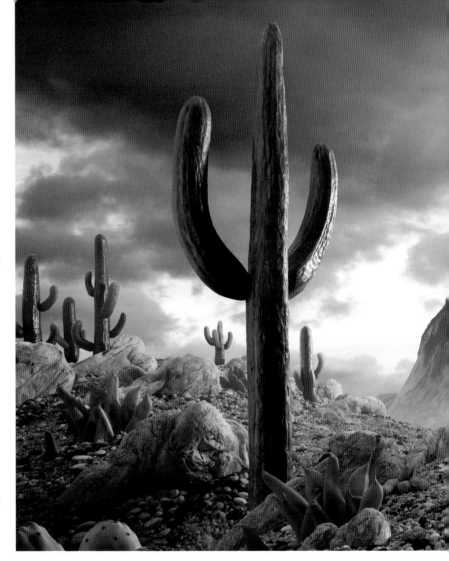

In the 1960s and '70s, our TV screens bombarded us with Hollywood Westerns, and playing cowboys and Indians in the school playground was a daily event for me and my childhood friends during lunchtime breaks. As I recall, none of the boys ever took on the role of the Indians, and so by default, the girls became our reluctant foe. As we shot at them from behind the rocks and cacti of patrolling "school dinner ladies," they frowned scornfully upon our prepubescent stupidity, patting their mouths not in war cry, but to conceal their yawns as they eagerly awaited the cavalry of our hormones to arrive.

The landscapes of these films were always vast and awe-inspiring as cinematographers showed off the great plains, mountains, and deserts of the Wild, Wild West, and although I later recognized that most of the locations were becoming all too familiar, they still captured a sense of the awesome scale and a rugged beauty of the place, creating an incredible visual backdrop that more than made up for the hammy acting.

It was these childhood impressions that I drew upon when asked to create some American scenes for the book, as not only was it a great challenge to make something that captured the size and grandeur of these landscapes, but also its harsh, inhospitable nature, which the cowboys and early settlers had to endure.

So with that in mind I began to sketch some ideas of what I wanted to include in the scene. The first of which was something I had been thinking about for some time, and that was to make cactus from courgettes (zucchinis), cucumbers, or pickled gherkins, the latter of which I first tasted back in the seventies when a well-known American burger restaurant opened up in my hometown. I distinctly remember that upon first bite of this long-awaited treat, my friends and I all winced as we bit into the crisp slice of green sourness

Above: The lonely desert wilderness.
Left: Carl lost in his desert of pickled-cucumber cacti.

that was hidden among the ketchup on top of the burger. Although I love them now, we all placed our future orders with "no gherkins!"

In another sketch I drew a covered wagon that would have a tortilla wrap or thin pancake for the canopy, and as this was the family mobile home for those early American frontiersmen, I liked the idea of placing it into a desert scene with the gherkin cacti in order to depict it not only as a symbol of civilization and a shelter from the elements, but also to show its vulnerability amid the savage wilderness of this formidable landscape.

The hardest job was to create the impression of enormous scale within the scene and so I recalled a favorite old Western with Gregory Peck and Omar Sharif called *Mackenna's Gold*, in which Peck leads a group of treasure hunters to a secret canyon where a massive seam of gold is exposed. This takes them through some of the incredible sandstone buttes of Monument Valley in Arizona and Utah, and I remember being blown away by these awesome rock formations, which feature so prominently in the latter part of the film. I knew I had to include these iconic structures into the scene, as not only would they be a great homage to those films of my childhood, but

INGREDIENTS

Cactus – gherkins, courgettes (zucchinis), pickled cucumbers
Foreground cacti – prickly pears
Covered Wagon – breadsticks, tortilla flour wrap
Wagon wheels – onion rings with pretzel spokes
Cowboys – avocado pears wrapped in bacon
Cowboy hats – hot dogs, pepperoni
Campfire – vanilla pods, cloves, ground nut rocks, Scotch bonnet peppers
Foreground rocks – ciabatta, crusty bread
Ground cover – buckwheat, black-eyed peas, pinto beans, kidney beans
Plants – runner beans
Mountains – oxtail, ribeye beef joint

I knew that they would bring that sense of scale and majestic beauty I was looking to portray. The problem now was what to make them from, and how big did they need to be in order to achieve this illusion?

When faced with these problems, my instinct is to go back to the dominant ingredient in the food culture of the place I am trying to re-create and this usually provides the answer or the direction to take toward that answer. In this case, my focus was drawn to the cattle, beef, and enormous steaks for which the American West is so well known, so I headed off to The Ginger Pig, a well-known butcher shop, one

Top: Carl meticulously arranging beans on the set.

Bottom: Probably my favorite sketch of all time, which captured perfectly the image that was in my head.

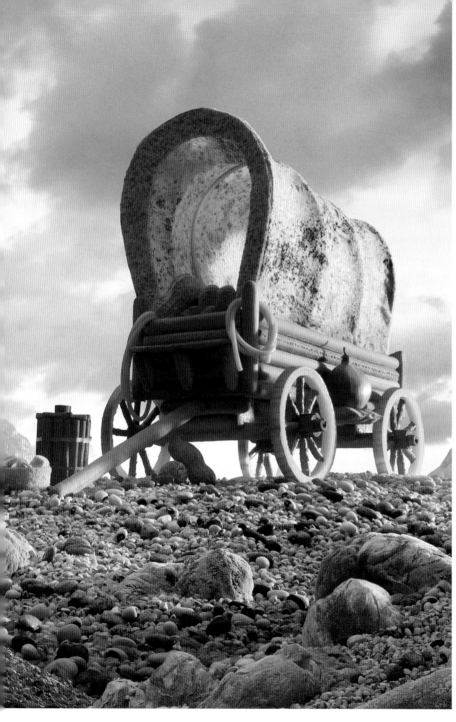

The covered wagon is a symbol of civilization as well as of shelter and sanctuary from the outside elements.

of which is situated in London's famous Borough Market, near to my studio.

I took the drawing with me to show one of the butchers what I was trying to do, and instead of making jokes about me being one sandwich short of a picnic, the young butcher seemed to understand my plight and promptly emerged from his cold store with a large joint of rib-eye beef, which he stood upright on the counter in front of me. "Wo'aba'tha" he proudly announced. "Perfect," I said, and promptly paid the £90 (about $145) he was asking for it. This was one ingredient that was certainly not going to be shared with the team after the shoot.

I also bought an oxtail to make one of the pinnacles to sit alongside the main butte as well as some skirt of beef with which to build up the bases of the stacks, and upon arrival back at the studio, my trusty model maker Paul appeared with a wonderful covered wagon complete with onion ring wagon wheels.

The foreground of the scene fell into place very quickly, especially after overlaying the drawing onto the screen, which made the assembly of the composition come together with ease, and although I had never featured people in previous scenes, I felt that

this image needed a front-and-center human element in order to bring a feeling of companionship and unity that I am sure was at the heart of the pioneering spirit. So avocados wrapped in bacon blankets with hot dog hats brought our "hammy" actors back to the Wild West once more.

Having shot the foreground and middle ground elements, it was time to get the rib-eye beef out of the fridge. Having lit it with the same sunlight source, I adjusted the lateral angle of the light upon the meat, which I hoped would enhance the feeling of distance and therefore scale. I also lowered the angle of the camera lens in order to give me more distortion and perspective so that the stack of beef appeared to tower above. Both these subtle changes together with a small amount of mist completed the illusion that brought the majestic beauty and awesome presence I was hoping for.

The final touch was to make smoke from the fire, which Paul provided from cigar smoke blown through a tube. I was happy with the first couple of takes, which were great, but it's always worth doing a dozen or so more, in order to get the green tinge into his cheeks.

Below: Early cowboys (our "hammy" actors) huddled around the campfire.

Left, top: Fixing the onion-ring wheels in place.

Left, center: Carl checking the exposure on his screen.

Left, bottom: Paul blowing smoke through a tube to create the campfire.

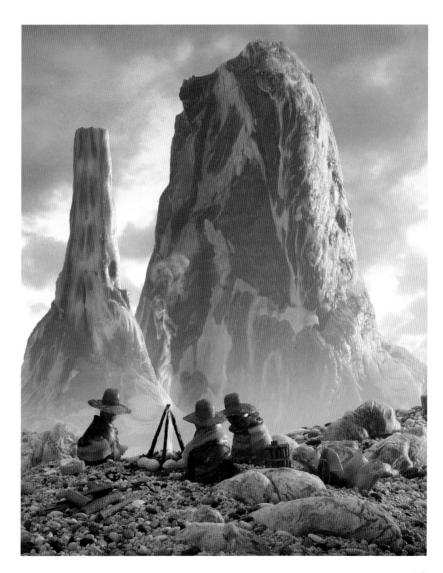

Coralscape

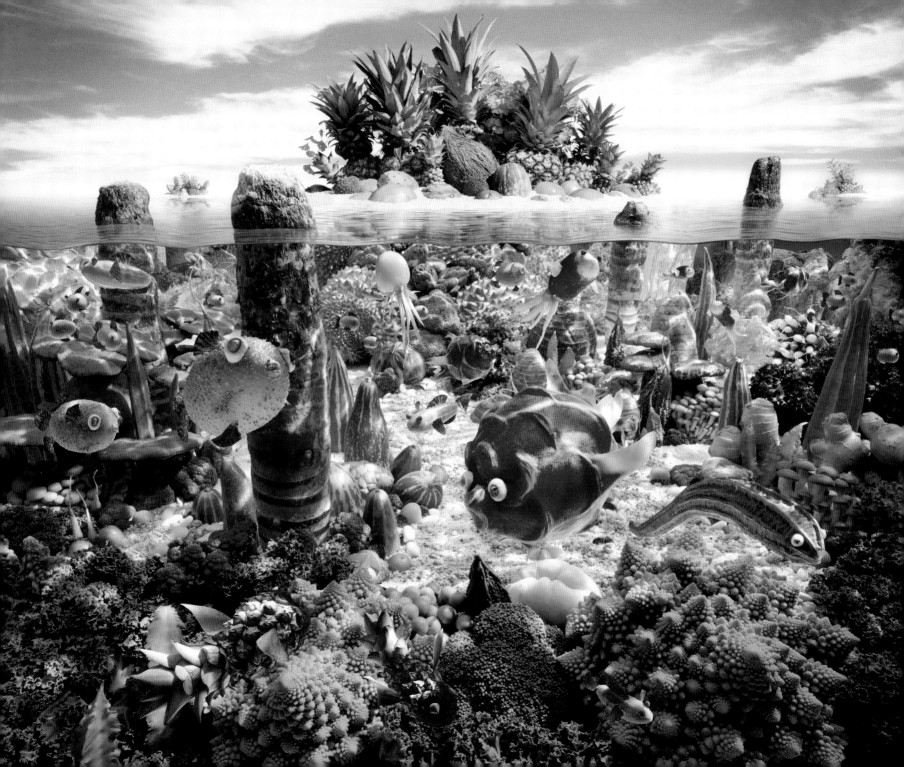

CORALSCAPE

INGREDIENTS

Coralscape
Island – *pineapples, coconuts, passion fruit, coriander and parsley, melons, lychees, kumquats, mangoes, lemons, limes*
Coral stacks – *yams*
Spiky rocks – *durians*
Sand – *rice, bulgur wheat, couscous*

Coral and plants:

ginger root, broccoli, snake gourd, pickling melon, Asian eggplants, oriental melon, chilies, Chinese dried mushrooms, Chinese white radish, Romanesco cauliflower, purple cauliflower, tomatoes, parsley, mushrooms, cabbage, limestone lettuce, Chinese long beans, lotus root

Fish:

dragon fruit, toddy palm seeds, prickly pears, longan, kumquats, star fruit, radishes, lychee, bean sprouts, Chinese cucumber, okra, baby pineapples

A technique used in an early image called Crab Cave was a sheet of rippled glass to create the illusion of looking above and below the surface of water. It was something that worked really well at the time and I knew it was something that I would employ again someday, and in September of 2009, that day arrived.

Having been fortunate enough to have scuba dived in the Red Sea off the Egyptian coast, I recalled the amazing contrast between the hot, dry, lifeless landscape of the coastline and the incredibly vivid underwater world of coral and tropical fish that lie in the clearest water I have ever swam in. So with this image I wanted to create that sense of two worlds, the one above the surface and the one below, but instead of a dry, arid landscape above the surface, I wanted the graphic simplicity of small tropical islands, made of course, from tropical fruit.

The best part of this shoot was the shopping. I spent hours walking around Chinese, Indian, and Asian supermarkets in London's Chinatown and Brick Lane, looking at all the different kinds of fresh and dried ingredients, many of which I had never seen before. During one of the three shopping trips I made for the shoot, I found durians. A durian is a large heavy fruit that has a hard, spiky outer shell for which the Chinese supermarkets provide heavy-duty gloves for picking them up. I could see instantly that these would make for perfect rocks to dress the coral and plant life around for my underwater scene, so I loaded five of them into my shopping cart (much to the amazement of my fellow shoppers). Upon arrival at the checkout, a small but very formidable Chinese manager began to question me about what I was going to do with them.

Upon finding out that I was going to photograph them, she became very concerned. "These are the kings of fruit," she exclaimed. "You'd better not throw them away!" I assured her that we would attempt to eat them, but as each one was the size of a soccer ball, she didn't seem too convinced. After wrapping the last one in newspaper she rung up the till and to my horror demanded £125 ($200)! I couldn't believe it, £25 each

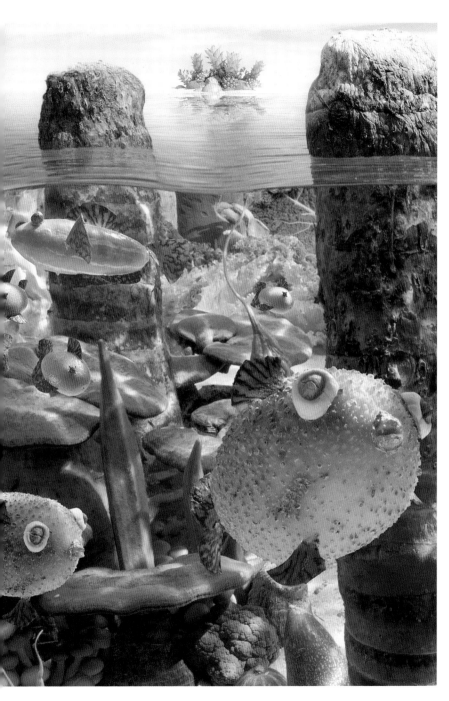

Left: A detail of our friendly puffer fish.

Right, top: Paul helping to lay down the rippled glass.

Right, bottom: Carl pushing a cocktail stick into a ginger plant to stop it from falling over.

Opposite: My drawing of the scene without the busy coral reef.

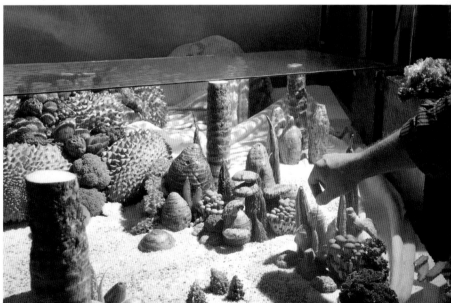

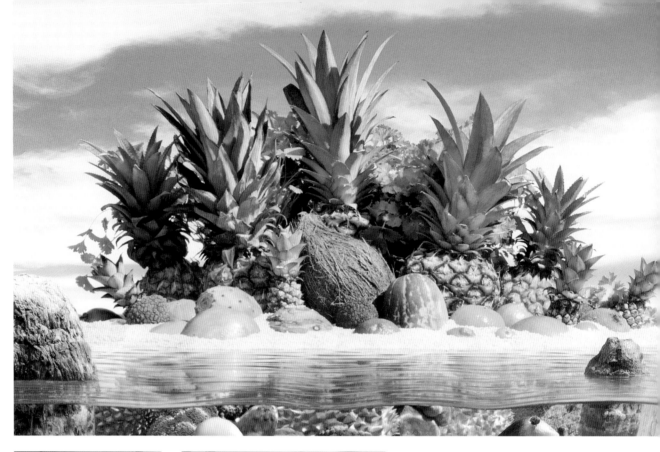

for a fruit that smells so bad when you open it up that some hotels in Asia have banned them from being eaten within the building! I smiled sweetly and handed over my credit card while she muttered something under her breath at me in Cantonese.

Back at the studio, the mountain of ingredients had piled up into a cornucopia of colors and textures (and, so my team tells me, odors), and as I had so painfully shopped for them, I wanted to use as many as I possibly could within the shot in order to create the blaze of colors, shapes, and forms I recalled from my diving experiences.

We began by laying down a bed of "sand" on the large triangular tabletop that Paul has constructed for most of my shoots. We used different types of rice and couscous for this, and in the middle of the seabed I stacked the durians up to form the base of the tropical island that would be built on top of the large sheets of rippled glass that would be suspended above the underwater set to form the surface of the water. This rippled glass is an absolute godsend, as it not only looks convincing as the surface of water when viewed from a low angle, but also acts as a wonderful medium for bending the light that passes through it to form

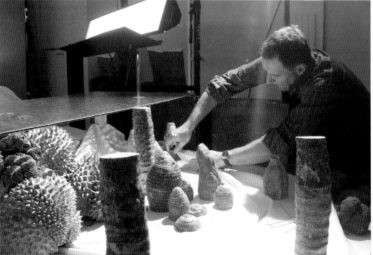

Above: A close-up of the tropical-fruit island.

Left: With the first layer of glass removed, Carl accesses deeper parts of the set to dress with ingredients.

Right, top: Carl and Paul building the scene (viewed from the back of the set).

Right, bottom: The underwater set in the studio.

the dapples of sunlight that we see underwater.

I then placed large yams into the set, having cut their tops off, on top of the glass in order to create a visual link between the two worlds. These pillar-like structures also help to give the image depth as markers of perspective through the underwater landscape. Once these were in place we began to fill up the set with all the marvelous things I had collected from my shopping sprees, some of which are so unrecognizable to a Western audience that they would be forgiven for thinking that this is not all food. The Romano broccoli is a great favorite of mine and I was glad to be able to use it so prominently in the foreground coral. Clusters of mushrooms, lychees, and okra also seem so at home as underwater plant life, it makes you question whether or not their aquatic counterparts do actually exist. Maybe they do!

Once the underwater scene was shot, we concentrated on the tropical islands, for which adorable baby pineapples, coconuts, and other exotic fruits quickly became our deserted island. Having put most of what was bought into the scene, I held back a few ingredients with the view to making them into tropical fish,

but as their placement would be so crucial, I decided to shoot them separately and add them in post so that I could play with their size and position to my heart's content. I particularly like the puffer fish and the jellyfish made from a lychee with bean sprout tentacles. But the most important fish is, of course, the pink one closest in, made using a dragon fruit. It is very important to me to have a focal point for the viewer to latch on to when confronted with such a visually busy scene. For me it is a way of guiding the eye to a safe stepping-stone within the image from which they can explore the scene further. This may be considered by some as being a bit too controlling in the way I am forcing the eye to access the image, but I believe that if you take someone to somewhere they have never been before, it is nice to hold their hand.

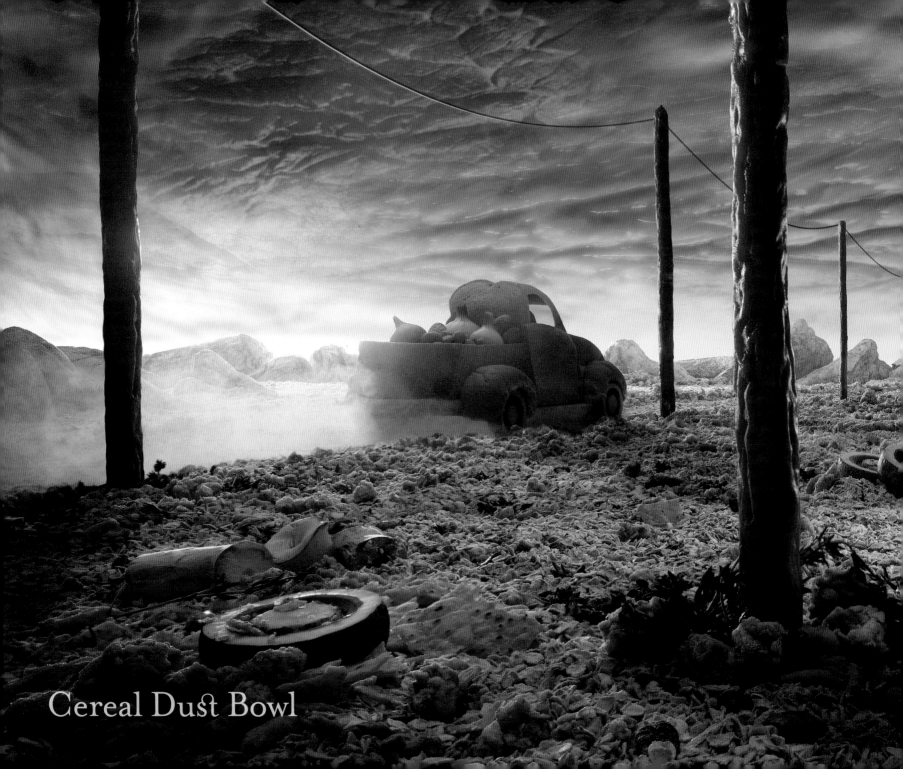

Cereal Dust Bowl

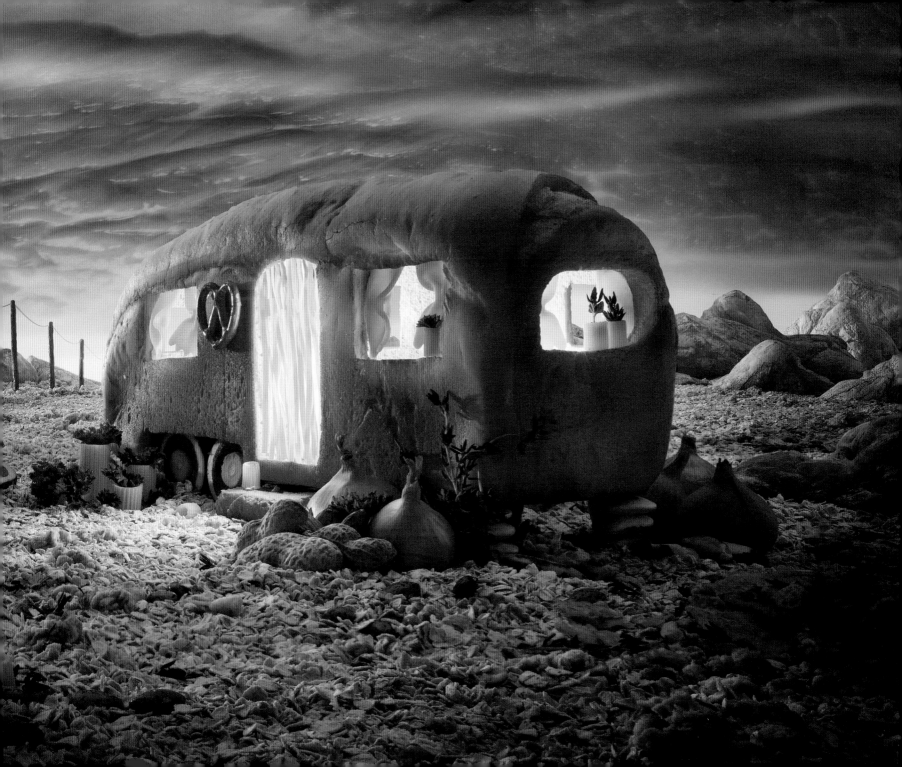

CEREAL DUST BOWL

Much of America is familiar to the rest of the world through the many movies made in its vast and varied landscape. So when asked to produce some scenes of America, the first images in my head were scenes of the Midwest, where telegraph roads stretch endlessly across the dry desert plains, and where the early pioneers stared bleakly into the abyss of this never-ending wilderness before they finally made it across the Rockies to the more fertile promised land of the West Coast.

When horses and covered wagons were long gone, they left in their stead the pickup truck, which was the workhorse vehicle, and the mobile home, which gave those with the pioneering spirit the freedom to explore and make their home where their hearts took them. As American design classics, these two symbols of self-sufficiency were beautifully encapsulated in the iconic shapes of the 1930s Airstream trailer and the Chevy pickup truck.

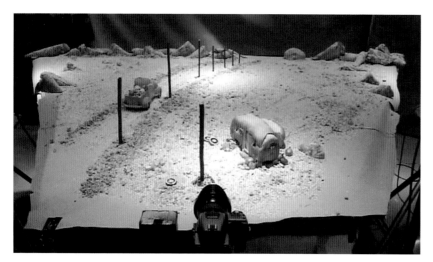

Now that I had my landscape and my subjects, I started to think about the food. The Airstream was easy, as it so resembles a loaf of bread, and as the Chevy needed to be cut from the same cloth, a smaller loaf and buns imitated perfectly the rounded shapes of both bumpers and hood. As I wanted to keep the image as simple as possible, it was important that the ingredients were not too varied, and true to the staple diet delivered by the agriculture of the Midwest. Cereals such as wheat and corn needed to be a big part of its makeup, so I covered the ground with oats and cereal, adding a few nuts and corn chips to give the impression of discarded materials and litter.

The other essential ingredient was, of course, beef. Americans are big meat eaters, and it was important to make sure that meat had a significant presence in the scene, and what better way than to use the texture and marbling of a big slab of steak as the underside of a cloud bank in the sky. I shot several steaks on a piece of glass and then flipped the image upside down so that it would hang over the scene, but the initial look was incredibly carnivorous and the streaks of fat in the meat made it look rather unpleasant, so with a bit of Photoshop tickling I applied a blurring to the fatty areas, and to my

pleasant surprise they took on the look of clouds moving across the sky with the beams of sunlight feathering through them, and this was much more pleasing to the eye.

By chance I found out about Slim Jims, a long sausage of cured meats popular in the United States, and so this gave me the chance to add even more meat, as they made perfect telegraph poles since their texture was so similar to that of wooden posts and tree bark. These were planted in diminishing sizes along the road to emphasize the feeling of distance and perspective.

Having scooped out the bread loaf, model-maker Paul wired up the Airstream with a small bulb to light up the interior, and added linguini and bowtie pasta curtains and mushroom wheels. Broad beans were stacked up underneath the chassis to keep it sturdy and level, and I decorated the area surrounding the trailer with a potted

INGREDIENTS

Airstream trailer and pickup truck – *crusty white loaf*

Telegraph poles – *Slim Jims, pepperoni*

Telegraph wires – *black spaghetti*

Rocks and distant hills – *ciabatta bread*

Tires – *mushrooms*

Ground cover – *oats, cereals*

Dressing around trailer – *monkey nuts, dried butter beans, shallots, dried pasta*

Plants – *parsley, thyme*

Sky – *rib-eye steak*

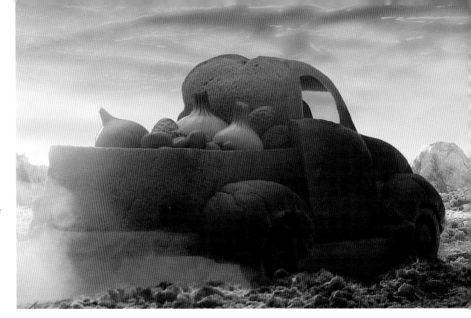

Right, top: The trail of dust behind the pickup was a last-minute achievement that brought the scene to life.

Right, bottom: A close-up of the airstream trailer.

Below: A drawing of the scene.

plant garden, some sacks of bronzed onions, and a few discarded mushroom tires. The pinnacle of the shoot came right at the end, when I realized that the chances of making the pickup truck look like it was moving with a dusty trail behind was going to be very difficult to achieve, so after sharing my concerns about this with Paul, he hurried off to his workbench like a man with a

mission, to fashion the lid of a takeout coffee cup and a piece of plastic tubing into a rig that would be filled with whole wheat flour and blown out from underneath the truck. After a 3, 2, 1, *go*! Paul blew and I fired the shutter. Seconds later the image appeared on the screen the way you see it now, with the sunlight beautifully flaring through the dust cloud. We did it again a dozen times, but this first shot was still the best, and for me it brought the scene to life.

The lighting of this scene was always a very important part in making this image. I wanted to create an atmosphere and mood that would ambiguously symbolize either the sun rising on a new day of hope and of living in the freedom of this pioneering spirit, or the sun setting at the end of the day on this way of life, to a time and era that has now been lost.

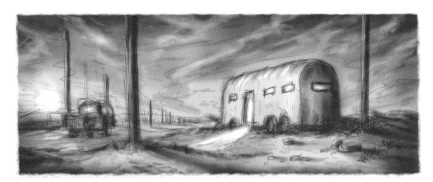

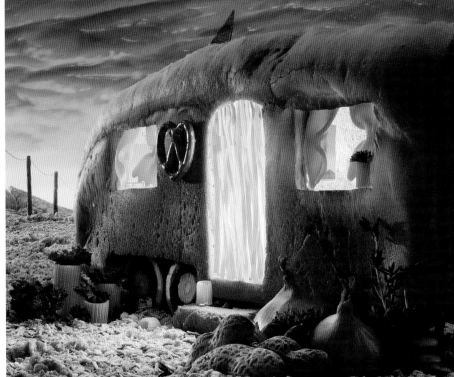

ACKNOWLEDGMENTS

I'd like to thank the following people for all their help, expertise, and support in making this book and all the work in it come into existence.

First and foremost I'd like to thank the extremely talented Mr. Paul Baker of 3D Models, not only for his hard work, dedication to his craft, and sheer bottomless pit of enthusiasm and energy, without which none of this would have happened, but also for his wise counsel and his clear, grounded thinking, not to mention his sometimes reluctant friendship, which I am very privileged to have more or less earned. I would also like to thank his right-hand man, Neil Jones, for making some of Paul's work look as good as it does, together with the rest of the lads from 3D Models.

On the model-making front, thanks also go to John Robertson and Simon Cole from Model Solutions who worked on the Tuscan scenes.

Huge, sloppy wet kisses and hugs with surgical rubber gloves go to my lovely food stylists without whose monumental patience and skills I would be lost. Firstly to the brave and wonderfully talented Joyce Harrison, who worked fearlessly on most of the early scenes. Secondly to the supremely gifted Peta O'Brien whose dry wit, warm heart, and outstanding professionalism make us all look like buskers. Thirdly to the lovely Rosie Scott, who fell into the role as if she'd been doing it for years, and finally to the wonderful Lorna Rhodes, who baked our beautiful Crockerville.

I'd also like to thank the retouchers for making my sometimes average photography look extremely presentable. Firstly to Miles and Bernie at what used to be Alchemy, for sharing the vision with the early work to boldly go where no fool had been before. To Tim Ashton at Happy Finish for Garlicshire, and especially to Steve Brown, whose patience I have tested into the early hours, but whose relentless talent as both a photographer and a retoucher is matchless in going way beyond my expectations.

I'd also like to thank all the assistants who have put up with my many ups and downs over the years, and an extra-special thanks to Dylan Collard, my onetime assistant and an awesome bass player turned photographer, friend, and confidant, whose tireless support and encouragement has been greatly appreciated.

For their patience and belief in me and my work, my thanks go to my agents, Julie and Rachel at Metcalfe Lancaster, Erica Z, Hortense at Art&Brand, Malcolm at Lenswall, and Alex Meisel. A very special thank-you goes to my literary agent Sorche Fairbank, who knew this book would eventually happen and made sure that it did. Thanks also to David Cashion and all at the Abrams "family" who have given me this great opportunity to share the work through this book, and to Gary Tooth at Empire Design Studio for making it look so good!

The biggest thank-you goes without a doubt to my long-suffering wife, Helen, without whose love, strength, faith, and great sanity, I would never have made it to where I am now.

My final thanks go to God for giving me the talent and supplying all the ingredients.

This book is dedicated to my four children, James, Thomas, Joseph, and Madeleine, who I hope will be inspired to follow their dreams, listen to their hearts, have faith in the knowledge that there is a better way, and the strength, courage, and determination to live for it.

BIOGRAPHY

Carl Warner was born in Liverpool, England, in February 1963, and at the age of six moved to the county of Kent. At school, he excelled in art classes, and after a foundation course at Maidstone Art College, he went to London to study photography, film, and television at the London College of Printing.

After completing his degree, Warner worked for several photographers in the advertising world, but shortly thereafter set out on his own as a still-life photographer. Over the past few years, he has concentrated on the food landscapes pictures, which are now being translated into moving images through various TV and animation projects.

Although he still operates from his studio in London, Warner lives in the Kent countryside with his wife and four children, whose fickle eating habits have inspired him to make food more interesting to children as well as adults in an attempt to encourage healthy eating.

Also a keen musician, Warner has played in many bands over the years and still keeps a large drum kit in his garage, which he plays on every day to relieve the frustrations of working with vegetables that won't quite behave themselves.

For more information, visit www.carlwarner.com.

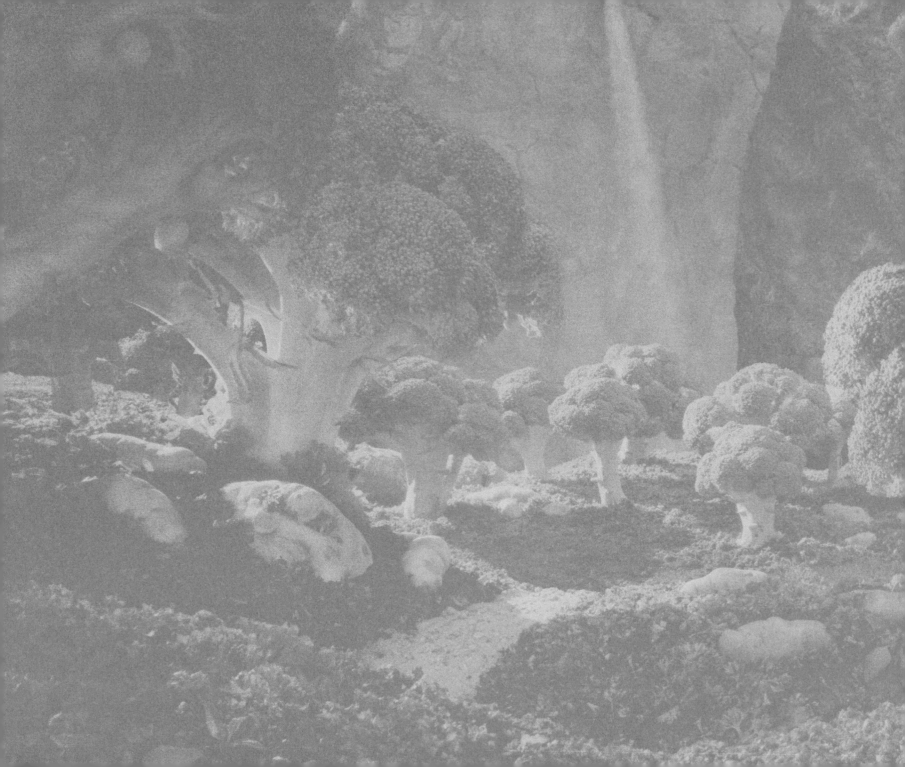